T0208144

The Total Art of Stalinism

The Total
Art of Stalinism

AVANT-GARDE, AESTHETIC
DICTATORSHIP, AND BEYOND

by
Boris Groys

Translated by Charles Rougle

VERSO

London • New York

This edition published by Verso 2011
© Verso 2011
Translation © Charles Rougle 1992
2011 afterword © Boris Groys
First published in English by Princeton University Press 1992
Originally published in German, translated from the Russian,
as *Gesamtkunstwerk Stalin*
© Carl Hanser 1988, Verlag München Wien

3 5 7 9 10 8 6 4 2

Verso
UK: 6 Meard Street, London W1F 0EG
US: 20 Jay Street, Suite 1010, Brooklyn, NY 11201
www.versobooks.com

Verso is the imprint of New Left Books

ISBN-13: 978-1-84467-707-8

British Library Cataloguing in Publication Data
A catalogue record for this book is available from the British Library

Library of Congress Cataloging-in-Publication Data
A catalog record for this book is available from the Library of Congress

Printed in the United States

CONTENTS

THE CULTURE OF THE STALIN ERA
IN HISTORICAL PERSPECTIVE

THE WORLD promised by the leaders of the October Revolution was not merely supposed to be a more just one or one that would provide greater economic security, but it was also and in perhaps even greater measure meant to be beautiful. The unordered, chaotic life of past ages was to be replaced by a life that was harmonious and organized according to a unitary artistic plan. When the entire economic, social, and everyday life of the nation was totally subordinated to a single planning authority commissioned to regulate, harmonize, and create a single whole out of even the most minute details, this authority—the Communist party leadership—was transformed into a kind of artist whose material was the entire world and whose goal was to "overcome the resistance" of this material and make it pliant, malleable, capable of assuming any desired form.

In the beginning of his *Discourse on Method* Descartes laments that he is too weak to organize rationally the life of the entire country or even a single city, and that first he must order his own thoughts.[1] The Marxist notion of the superstructure, of course, proclaims the impossibility of changing the state of one's own thought without changes in the social base that determine this thought, that is, the type of social organization in which the thinker lives. To the revolutionary Marxist, individuals, their thought, and "inner world" in general are merely part of the material that is to be ordered— new rational thought can only arise out of a new rational order of life itself. But the very act of creating the new world is consequently irrational and purely artistic. The creators of

this new world, after all, cannot claim complete rationality for their project, since they themselves were shaped in a reality that was not yet harmonious. All that distinguishes the artist-ruler from the crowd of ordinary mortals is the knowledge that the world is elastic and that therefore everything that to the average person seems stable and immutable is in reality relative and subject to change. It is total power over society that shields the creator of the new life from all possible criticism. Since critics occupy only a particular position in society, they do not have the overarching view of the whole that only power can provide. Their criticism, therefore, can only arise from remnants of the old social order in their thought or from one-sided views incapable of grasping the artistic whole of the new world. Here the perspective of power and aesthetic distance coincide. If, as Nietzsche assumed, the world as it is can only be justified aesthetically, then it is even more true that only such a justification is possible for the building of a new world.

Similar aesthetic reorganizations of society have been proposed and even tried more than once in the West, but it was in Russia alone that such a project was first completely successful. Each revolution in the West was in one way or another succeeded by counterrevolution ending in the establishment of an order that inherited the old even though it included elements of the new. Revolution in the West could not be as radical as in the East, because Western revolutionary ideology was too aware of its debt to tradition, too heavily relied on previous intellectual, social, political, technical, and other achievements, too highly valued the circumstances that generated it and in which it was first articulated. For this reason, no Western upheaval could equal the Russian Revolution's merciless destruction of the past. Revolutionary ideology was imported into Russia from the West and had no real Russian roots of its own. Relative to the developed countries, in fact, the Russian tradition was associated with backwardness and humiliation, evoking disgust rather than compassion among the majority of the intelligentsia, and, as became clear in the course of the Revolution, among the people as well.

As early as Peter's reforms in the early eighteenth century, the Russian people showed how ready and relatively willing they were to abandon their seemingly deep-rooted tradition in favor of Western innovations if these promised rapid progress. Because it was associated with backwardness and a feeling of inferiority, this purely aesthetic distaste for the old accounts for the fact that Russia was more receptive than the West itself to new artistic forms, since by assimilating them rapidly the Russian intelligentsia could compensate for its inferiority complex and regard the West as culturally backward. Because it took place in a technologically and culturally backward country, the Russian Revolution was often viewed from rationalist Marxist positions as a paradox. Russia, however, was aesthetically far better prepared for revolution than the West; that is, it was far more willing to organize all life in new, as yet unseen forms, and to that end it allowed itself to be subjected to an artistic experiment of unprecedented scale.

Although they remained unrealized, the first projects of this experiment drawn up by the practitioners and theoreticians of the Russian avant-garde now enjoy a firmly established position in art history and have evoked universal and deserved admiration for their daring radicalism. True, the Russian avant-garde is still little studied: beginning in the 1930s much of what it created was destroyed, and, liberalizations notwithstanding, even today its works are not readily accessible either to the public or specialists. Especially in recent years and above all through the efforts of Western researchers, however, the avant-garde has become a universally recognized subject of serious research. Socialist realist art, that is, the art of the Stalin era that succeeded the avant-garde in the 1930s, has thus far met a different fate. The slogan of "socialist realism" has been regarded by independent historiography both within the Soviet Union and elsewhere as merely a bugaboo used by the censorship to persecute and destroy "genuine art" and its creators. Viewed from this perspective, the entire Stalin period is one long martyrology or history of persecutions, which it indeed undoubtedly was. The real issues, however, are in the name of what all this per-

secution took place, and what sort of art was canonized and why. Strange as it may seem at first glance, these questions are far more difficult to answer than in the case of the classical Russian avant-garde.

In the Soviet Union today, the art of the Stalin period is officially no less taboo than the art of the avant-garde. Most of the newspapers, books, and journals of the time are in "special archives" inaccessible to the ordinary researcher; pictures hang alongside those of the Russian avant-garde in the likewise inaccessible storerooms of the museums. Many of them have been repainted by their authors to delete Stalin and other compromised leaders of the time. Numerous sculptures, frescoes, mosaics, and buildings were simply destroyed in the process of de-Stalinization. Complicating the situation in comparison to that of the avant-garde, however, is that the doctrine of socialist realism remains as official and obligatory for all Soviet art as ever, and has retained all the formulas dating from the Stalin years. These formulas, however, are interpreted more "liberally" today, since they can be made to accommodate artistic phenomena that would have been excluded under Stalin. Soviet critics do not acknowledge these new interpretations as such, but declare that they were inherent in socialist realism from the beginning and were merely "distorted" in the Stalin years. Here no mention is made of the fact that it was during these same years that the doctrine came into being. Thus the history of the formation and evolution of socialist realism is distorted beyond recognition to meet the most important political demands of the "current situation." Moreover, although the abundance of official literature on the theory of socialist realism may convey the impression that a great deal has been said about it, this entire literature tends less to analyze than to exemplify its mechanisms—Soviet aesthetic theory, as has often been the case with other twentieth-century artistic movements, is an integral component of socialist realism rather than its meta-description.

Quite apart from all these difficulties, however, interest in the aesthetics and practice of socialist realism has been inhib-

ited by a question which, for that matter, also arises in the case of certain other artistic currents in the 1930s and 1940s, such as Nazi art in Germany: Are we really dealing with art here? Is it in fact even morally defensible to consider together with other artistic tendencies these movements—which have served repressive regimes and achieved hegemony through the physical elimination of their opponents?

These questions undoubtedly arise out of a rather naive and "rosy" notion of art that gradually gained currency in twentieth-century aesthetics. According to this view, art is an activity that is independent of power and seeks to assert the autonomy of the individual and the attendant virtues of individual freedom. Historically, however, art that is universally regarded as good has frequently served to embellish and glorify power. Even more important is the fact that refusal to acknowledge the art of the avant-garde—which made its creators outsiders—by no means implies that these artists consciously aspired to such a position or that they lacked the will to power. An attentive study of their theory and practice indicates quite the contrary—it is in avant-garde art that we find a direct connection between the will to power and the artistic will to master the material and organize it according to laws dictated by the artists themselves, and this is the source of the conflict between the artist and society. Recognition of the artist by the art historian, the exhibition of works in museums, and so on, indicates that the artist has lost this conflict, and it is at the same time a compensation from the victor (that is, society) that establishes the fact of the defeat once and for all. The victory of the artist, even in an alliance with the power of the state, naturally arouses the indignation of society and the desire to exclude the artist from its pantheon of heroes. Thus socialist realism (like Nazi art, for example) finds itself in the position to which the avant-garde originally aspired—outside the museums and art history and set apart from traditional and socially established cultural norms. This art retains its virulence as such a total alternative, and, since the logic of contemporary postmodernist culture no longer recognizes the right of art to be virulent, today it and the avant-garde must

both be viewed in their historical perspective. Such histori-
cization, of course, does not mean forgiving this art its sins.
On the contrary, it means that we must reflect both upon the
supposed absolute innocence of the avant-garde that fell vic-
tim to this culture and upon the irreproachability of the mod-
ernist artistic intention as such, of which the twentieth-cen-
tury avant-garde is merely one of the most colorful historical
manifestations.

The myth of the innocent avant-garde also rests upon the
rather widespread view that the totalitarian art of the 1930s
and 1940s is a simple return to the past, a purely regressive
reaction to a new art that was unintelligible to the masses.
According to this theory, the emergence of socialist realism
reflects the rising hegemony of these masses after the almost
complete disappearance of the European-educated intellectual
elite amid the terror of the Civil War, emigration, and the
persecutions of the 1920s and 1930s. In this interpretation,
which appears to be confirmed by the then widespread slogan
"learn from the classics," socialist realism is simply a reflec-
tion of the traditionalist tastes of the masses. The obvious
dissimilarity between socialist realist works and their classi-
cal models then leads to the assertion that the doctrine is an
unsuccessful throwback, simply kitsch, a "lapse into barbar-
ity," whereafter the art of socialist realism is serenely rele-
gated to the realm of "non-art."

Whatever else the 1930s and 1940s in the Soviet Union
may have been, however, they were not a time in which the
actual tastes of the people were allowed free and uninhibited
expression. Then as well, the masses were attracted to Holly-
wood comedies, jazz, novels depicting the "good life," and so
on, but they were not drawn toward socialist realism, which,
because it was meant to educate, was unappealingly didactic,
devoid of entertainment value and divorced from real life no
less completely than Malevich's *Black Square*. If millions of
Soviet workers and peasants in those years could study such
laws of Marxist dialectics as the "transition from quantity to
quality" or the "negation of the negation," we may safely
assume that they would not have protested or been greatly

surprised if they had in addition been called upon to study suprematism or the *Black Square*. Anything canonized by Stalin—even the phonetic "transrational" poetry of Khlebnikov or Kruchenykh—would undoubtedly have been greeted with equal enthusiasm.

Socialist realism was not created by the masses but was formulated in their name by well-educated and experienced elites who had assimilated the experience of the avant-garde and been brought to socialist realism by the internal logic of the avant-garde method itself, which had nothing to do with the actual tastes and demands of the masses. The basic tenets of the socialist realist method were developed in extremely involved and highly intellectual discussions whose participants very often paid with their lives for an infelicitous or inopportune formulation, and this of course increased even more their responsibility for each word they uttered. Today's reader is struck above all by the relative proximity of the positions in this debate, which to the participants themselves, of course, seemed mutually exclusive. This similarity between the views of the victors and their victims obliges us to regard with particular caution any unambiguous oppositions between them arising from a purely moral interpretation of events.

The turn toward socialist realism was moreover part of the overall evolution of the European avant-garde in those years. It has parallels not only in the art of Fascist Italy or Nazi Germany, but also in French neoclassicism, in the painting of American regionalism, in the traditional and politically committed English, American, and French prose of the period, historicism in architecture, the political and commercial poster, the Hollywood film, and so on. Where socialist realism differs from these is above all in its radical methods and a monolithic style that nowhere (with the possible exception of Germany) was applied with such consistency across all areas in the life of society. Under Stalin the dream of the avant-garde was in fact fulfilled and the life of society was organized in monolithic artistic forms, though of course not those that the avant-garde itself had favored.

The gradual disintegration of these forms after Stalin's death resulted in the undecided and insecure Soviet culture of today. This culture focuses primarily on "restoring historical continuity," that is, on a neotraditionalism based both on the real experience of nineteenth-century Russian culture and on the writings of relatively traditionalist authors of the 1920s such as Mikhail Bulgakov and Anna Akhmatova. In this climate, the break with the past and utopianism are regarded as fateful errors, so that both the avant-garde and socialist realism are commonly defined with a reference to Dostoyevski's famous novel *The Possessed* simply as "nihilist insanity." It is no accident, therefore, that the aesthetics of the Russian avant-garde and socialist realism presently arouse more interest in the West than in the Soviet Union. Such problems are not only officially taboo but are also off limits to independent public opinion, which would rather forget past mistakes than open still unhealed wounds. Here the neotraditionalists would like to ignore the fact that they are in effect imposing a new canon upon culture and society, for they are as deeply convinced that they have comprehended the true spirit of the past as the avant-garde was sure that it had understood the true spirit of the future. Their moral indignation with the avant-gardist "will to power" prevents them from seeing that they are themselves repeating that same ritualistic artistic incantation of society in order to conquer and reorganize it in new forms (which in this case are supposedly old but actually no longer exist—if indeed they ever did).

Especially interesting here is the phenomenon of the Soviet postmodern (neomodernist rather than neotraditionalist) art that emerged in Moscow in the early 1970s. The representatives of this "sots art," as it is sometimes referred to with a term deriving from the combined names of socialist realism (*sotsrealizm*) and pop art, are artists and writers standing outside official cultural production who aspire to reflect the structure of that culture in their works.[2] This movement, which uses quotation and conscious eclecticism and delights in the spectacle of antagonistic semiotic and artistic systems destroying each other, is very much in line with the general

postmodernist aesthetics of 1970s and 1980s European and American art. At the same time, however, it displays certain important distinctions dictated by the specific conditions in which it arose and developed. First of all, opposing it is not a commercial, impersonal art that responds to and simultaneously strives to manipulate spontaneous consumer demand, but the art of socialist realism, which markets not things but ideology. Socialist realism, moreover, feels free and independent of the potential consumer, since marketing conditions rule out the possibility that the ideology will not be bought. The art of socialist realism has already bridged the gap between elitism and kitsch by making visual kitsch the vehicle of elitist ideas, a combination that many in the West even today regard as the ideal union of "seriousness" and "accessibility." Western postmodernism was a reaction to the defeat of modernism, which could not overcome commercial, entertaining kitsch, but after World War II was, on the contrary, increasingly integrated into the single stream of commercial art controlled by the demands of the market. It was this circumstance that prompted many artists to undertake a skeptical revaluation of values and renounce the modernists' totalitarian claims that they represented a chosen elite and new priesthood. These pretensions have now been succeeded by others, as individual creation is repudiated in favor of quotation and ironical play with the extant forms of commercial culture. This shift, however, is intended merely to preserve the purity of the artistic ideal. Purity was previously attained through the search for new individual and "incomprehensible" forms. Today, however, since that quest has been appropriated and is encouraged by the market, the artist turns in the name of purity and independence to the trivial, regarding this reorientation as a new form of resistance to the will to power he perceives in others but not in himself.

Soviet sots art, in contrast, arose in a situation in which the complete triumph of modernism dispelled all illusions of purity and impeccability. The artist realizes, therefore, that quotations and the renouncing of novelty and originality in favor of the "other" and "the trivial" express an artistic intent that

is inseparable from a striving for power. The Soviet artist cannot oppose himself to power as something external and impersonal, as the Western artist can do vis-à-vis the market. In the Soviet politician aspiring to transform the world or at least the country on the basis of a unitary artistic plan, the artist inevitably recognizes his alter ego, inevitably discovers his complicity with that which oppresses and negates him, and finds that his own inspiration and the callousness of power share some common roots. Sots artists and writers, therefore, by no means refuse to recognize the identity of artistic intent and the will to power at the source of their art. On the contrary, they make this identity the central object of artistic reflection, demonstrating hidden kinship where one would like to see only morally comforting contrast.

The contemporary artistic reflection on the Soviet order as a work of state art reveals a great deal in the system that is inaccessible by other means but that can also be approached only through the history of this state art. Hence the dual goal of the present study, which will attempt to conceptualize and explain and interpret both the artistic experience of constructing the new life in the pre-Stalin and Stalin periods and the artistic experience of reflection on this experiment. Stalinist culture will be considered historically, defined by the frame of the preceding avant-garde art and the following postutopian art, to which sots art belongs. By historical consideration, however, I do not mean the sort of detailed chronology of historical facts that has increasingly attracted historians of Soviet culture. Although this interest is legitimate and has produced significant studies, purely cultural phenomena approached in this way sometimes lose the inherent logic connecting them, and the internal evolution of the artistic project is supplanted by a description of meetings, resolutions, appointments, and arrests that in themselves are merely symptoms of this evolution. The decisive role of such facts in most historical descriptions of the period reflects the the outside observer's fascination with the ceremonies of the centralized Soviet bureaucratic apparatus. These, however, are in fact only a façade concealing real social processes, even if the ap-

paratus outwardly claims that its decisions are of crucial significance to such processes.

In the present study, therefore, consideration in the historical context will mean an attempt to establish a conceptual pattern by which the internal evolution of Stalinist culture may be understood. We shall be obliged to take account of the limits of that culture, because it is there that its problems and premises stand out most clearly; what I am proposing, in other words, is a kind of cultural archeology. Unlike that of Foucault, however, it will attempt to describe not only successive paradigms but also the mechanism of their succession. Because it inevitably involves certain simplifications and generalizations, such an approach would be unacceptable were it not guided by the hope not only that an interpretation of known facts will contribute to understanding them, but also and above all that a novel elucidation of the period will draw attention to things not even considered facts by the usual descriptive method; in this sense facts will not be neglected but will on the contrary be multiplied. In considering the periods of the avant-garde and socialist realism, I shall be focusing more attention on the artists' self-interpretation than on their already relatively well-known works; in the section devoted to the present, on the other hand, I shall attempt to provide a more detailed presentation of postutopian artistic practice.

My selection of examples may appear rather subjective, although here I have been guided less by personal taste than by the desire to reflect objectively the processes in contemporary Russian culture that I consider most relevant to the problems at hand. I do not rigorously distinguish between authors presently working within and outside the Soviet Union, as under contemporary conditions and for the writers considered here such a distinction is not essential.

THE RUSSIAN AVANT-GARDE:
THE LEAP OVER PROGRESS

IN RUSSIA as elsewhere, the art of the classical avant-garde is too complex a phenomenon to be wholly embraced by a single formula; but it does not seem an extreme simplification to define its basic spirit in terms of the demand that art move from representing to transforming the world. The readiness of European artists down through the centuries to lovingly copy external reality—their will to ever more perfect mimesis—was based on an adulation of Nature as the whole and consummate creation of the one and only God that the artist must imitate if his or her own artistic gift were to approximate the divine. The intrusion of technology into European life in the nineteenth century caused this picture of the world to disintegrate and gradually led to the perception that God was dead, or rather that he had been murdered by modern technologized humanity. As the world unity guaranteed by the creative will of God disappeared, the horizon of earthly existence opened, revealing beyond the variety of visible forms of this world a black chaos—an infinity of possibilities in which everything given, realized, and inherited might at any moment dissolve without a trace.

Of the Russian avant-garde, at least, we can state with certainty that its entire artistic practice was a reaction to this most momentous event of modern European history. Contrary to what is often maintained, the Russian avant-garde was far from enthusiastic about technology or inspired by a naive faith in progress. From the outset, it was on the defensive rather than the offensive. Its paramount task was not to destroy but to neutralize and compensate for the destructive effect of the technological invasion. Earlier unfriendly critics

and many sympathetic modern observers who felt they must praise the avant-garde for its "demonism" were in error when they portrayed it as inspired by a destructive, nihilist spirit or burning with incomprehensible hostility toward everything "sacred" and "dear to the heart." Avant-gardism differed from traditionalism not because it reveled in the ravages wrought by modern technological rationalism, but because it believed that this destruction could not be resisted by traditional methods. If the avant-garde followed Nietzsche's maxim to the effect that what is falling should still be pushed, it was only because it was deeply convinced that the fall could not be broken. The avant-garde regarded the destruction of the divine work of art that had been the world as an accomplished and irreversible fact whose consequences had to be interpreted as radically as possible if any compensation were to be made for the loss.

WHITE HUMANITY

One good example of this avant-garde strategy is the artistic practice of Kazimir Malevich, who in his well-known work "On the New Systems in Art" (1919) wrote: "All creation, whether of nature or of the artist, or of creative man in general, is a question of constructing a device to overcome our endless progress."[1] Thus Malevich's avant-gardism is reflected least of all in a desire to be in the vanguard of progress, which he regards as leading nowhere and therefore as completely meaningless. At the same time, he considers that the only way to stop progress is, as it were, to outstrip it, finding ahead rather than behind it a point of support or line of defense offering an effective shield against it. In order to find something irreducible, extraspatial, extratemporal, and extrahistorical to hold on to, the process of destruction and reduction must be taken to the very end.

This irreducible something was, to Malevich, the "black square," which for a long time became the most famous symbol of the Russian avant-garde. The *Black Square* is, so to speak, a transcendental painting—the result of the pictorial

reduction of all possible concrete content. In other words, it is a sign for the pure form of contemplation, which presupposes a transcendental rather than an empirical subject. The object of this contemplation is to Malevich nothing (that nothing toward which he felt all progress was moving), which coincided with the primordial substance of the universe, or, in other words, with the pure potentiality of all possible existence that revealed itself beyond any given form. His suprematist paintings, which represent the differentiation of this primordial form of the *Black Square* according to purely logical, "unearthly" laws, describe the "nonobjective world" that exists on a different level than the world of sensual forms. The fundamental thesis of Malevich's aesthetics is the conviction that the combination of these pure, nonobjective forms "subconsciously" determines both the relationship between the subject and all that is seen and the overall situation of the subject in the world.[2] Malevich assumes that in both nature and classical art the original suprematist elements were in "correct" harmonious relationships, although artists did not realize or consciously reflect this fact. The technological invasion destroyed this harmony, making it necessary to reveal these previously subconsciously operating mechanisms in order to learn to control them consciously and attain a new harmony in the new technological world by subjugating it to the single organizing and harmonizing will of the artist. The loss that technology caused the world was thus also to be compensated technologically, and the chaotic character of technological progress would be succeeded by the single total project of reorganizing the entire universe, in which God would be replaced by the artist-analyst. The goal of this total operation was to halt all further development, labor, and creation forever. Arising out of all this is a new "white humanity." The consciousness of "white humanity" is nonobjective, free of all desire to move toward any ideal or concrete salvation. According to Malevich, the spectacle of the "nonobjective world," that is, the vision of absolute nothingness as the ultimate reality of all things, would cause "the prayer to die on the lips of the saint

and the sword to fall from the hand of the hero,"[3] for this vision consummates history.

First of all, however, all art must cease. Malevich writes: "Every form of a spiritual world that is created should be built according to a general, single plan. There are no special rights and liberties for art, religion or civil life."[4] The loss of these rights and freedoms, however, is not a real loss, since man is originally unfree. He is a part of the universe, and his thought is directed by unconscious "stimuli" that give rise both to the illusion of "inner existence" and the illusion of "external reality."[5] All aspirations to knowledge are illusory and ridiculous, since they involve an attempt to use thoughts arising from hidden "stimuli" to study "things" that also arise from these stimuli, which in both cases necessarily remain hidden. "Investigating reality means investigating what does not exist and is incomprehensible."[6] Only the suprematist artist is capable of controlling, modifying, or harmonizing these hidden stimuli, since only he or she knows the laws of pure form.

Malevich repudiates religion and science, because they belong to the realm of the conscious rather than the subconscious. Significantly, in his late works he perceives the only rival of the artist to be the state, and here he evidently means a totalitarian state of the Soviet type. The state also appeals to the subconscious: "The state is an apparatus by which the nervous systems of its inhabitants are regulated."[7] He does not fear the competition of the state, however, because he trusts official Soviet ideology when it maintains that it is based on science and is striving for technological progress. In Malevich's view, therefore, the Soviet ideologist falls into the same category as the priest and the scientist, whose successes, because they are oriented to consciousness and history, are always temporary and consequently inevitably generate a variety of religions and scientific theories. The artist, by contrast, is oriented toward the subconscious: "If it is true that all works of art come from the action of the subconscious center, then it may be stated that the center of the subconscious is more accurate than the center of consciousness."[8] Here

Malevich is obviously incorrectly equating Soviet ideology
with ordinary liberal rationalism. Soviet Marxism similarly
assumes the subconscious determinacy of human thought, al-
though it seeks it not in the visual but in the social organiza-
tion of the world. Thus this ideology is a more serious compet-
itor for influence on the "nervous system" than many had at
first assumed.

Malevich's approach to art, which I have presented above
only in brief outline, is characteristic of his time and is merely
expressed more radically by him than by others. Thus another
leading representative of the Russian avant-garde, Velimir
Khlebnikov, assumed that the ordinary forms of language
concealed a purely phonetic "transrational" language that
worked secretly and magically upon the listener or reader. He
undertook to reconstruct this "language of the subconscious,"
as Malevich would have called it, and to master it con-
sciously.[9] Like Malevich's suprematism, Khlebnikov's pho-
netic transrational language, which went farther than any-
thing at the time (or perhaps at any time) in overcoming ordi-
nary linguistic forms, claimed universality and the ability to
organize the entire world on a new audial basis. Khlebnikov
called himself "Chairman of the World" and the "King of
Time," since he thought he had discovered the laws that de-
limit time and separate the new from the old in the same way
as such division is possible in space. Knowledge of these laws
would grant the avant-garde power over time and allow it to
subject the entire world to this power.[10]

Even outside avant-gardist circles, however, it is possible to
find contemporary parallels to Malevich's principal ideas.
Thus his reductionism resembles Husserl's phenomenological
reduction, the logical reductionism of the Vienna Circle, and
Lev Tolstoi's call to simplification; all of these seek to find a
minimal but real point of support, and all turn to the "ordi-
nary," the "folk" (Malevich arrived at suprematism by way of
folk art, the icon, and the signboard),[11] and all share an "anti-
progressionist" spirit. Malevich is even more reminiscent of
the neognostic "theurgy" of Vladimir Solov'ev, who defined
the meaning of art as "life-building" and believed that the art-

ist is capable of discovering the latent harmony of all things that will not be universally revealed until after the apocalypse.[12] According to Solov'ev, people are in the power of cosmic forces and can be saved only together with the entire universe in a single apocastasis that will neither add to nor remove anything from the world, but will simply unveil the hidden harmonious relationship among all things within it. Here is one certain source of Malevich's insistence that harmonizing "materials" and pure color sensations must be made "visible," as if perceived from a different, apocalyptic, otherworldly, posthistorical perspective.

The novelty of the contribution made by avant-gardists such as Malevich and Khlebnikov, however, is not apparent from such parallels. Central here is the radical notion that the subconscious dominates human consciousness and can be logically and technically manipulated to construct a new world and a new individual. It is on this point that the early avant-garde of Malevich and Khlebnikov was radicalized by their followers, who considered that suprematism and transrational poetry were too contemplative, since, although they contemplated the inner "subconscious" construction of the world rather than its external image, they did not break completely with the cognitive functions of art. Rodchenko's later constructivism reinterprets suprematist constructions as immediate expressions of the artist's organizing, "engineering" will, and Boris Arvatov, a theorist of the later, productionist variant of constructivism, speaks of the engineering nature of Khlebnikov's poetry.[13] The line of defense constructed by Malevich and other early avant-gardists was thus rather easily overrun by technological progress, which readily availed itself of the radical technical apparatus that had been designed to engage it in a final and decisive struggle.

RED AGITATION

The absolute zero that was to mark the beginning of a new world in which the new "white humanity" would be cleansed of all previous images, leave its former dwellings, and resettle

the suprematist *Planits*, was for Malevich still a matter of ar-
tistic imagination. After the October Revolution and two
years of civil war, however, not only the Russian avant-garde
but practically the entire population of the former Russian
Empire correctly perceived that this zero point had actually
been reached. The country was reduced to ashes, normal life
was utterly disrupted, housing was uninhabitable, the econ-
omy had reverted almost to the primitive state, social relations
had disintegrated, and life gradually began to resemble a war
of everyone against everyone. In the famous phrase of Andrei
Belyi, "the victory of materialism in Russia resulted in the
complete disappearence of all matter." Thus suprematism no
longer needed to prove what had become an obvious truth,
namely that matter as such is nothing. Since it seemed that the
apocalypse had come and that things had been displaced to
reveal themselves to the apocalyptic vision of all, the avant-
gardist and formalist theory of the "shift" that lifted things
from their normal contexts and "made them strange" by
deautomatizing perception and rendering them "visible" in a
special way was no longer merely the basis of avant-garde
art but an explanation of the Russian citizen's everyday
experience.

In this unique historical situation the Russian avant-garde
perceived not only an undeniable confirmation of its theoreti-
cal constructs and aesthetic intuition, but also a singular op-
portunity for translating them into reality. A majority of
avant-garde artists and writers immediately declared their full
support for the new Bolshevik state. Because the intelligentsia
as a whole were hostile toward this state, representatives of
the avant-garde occupied a number of key posts in the new
centralized administration of Soviet cultural life. This rush for
political power derived not merely from opportunism and the
desire for personal success on the part of the avant-garde, but
followed from the very essence of the avant-gardist artistic
project.

Traditional artists who aspire to re-create various aspects
of Nature can set themselves limited goals, since to them Na-
ture is already a completed whole, and thus any fragment of it

is also potentially complete and whole. Avant-garde artists, on the other hand, to whom the external world has become a black chaos, must create an entirely new world, so that their artistic projects are necessarily total and boundless. To realize this project, therefore, artists must have absolute power over the world—above all total political power that will allow them to enlist all humanity or at least the population of a single country in this task. To avant-gardists, reality itself is material for artistic construction, and they therefore naturally demand the same absolute right to dispose of this real material as in the use of materials to realize their artistic intent in a painting, sculpture, or poem. Since the world itself is regarded as material, the demand underlying the modern conception of art for power over the materials implicitly contains the demand for power over the world. This power does not recognize any limitations and cannot be challenged by any other, nonartistic authority, since humanity and all human thought, science, traditions, institutions, and so on are declared to be subconsciously (or, to put it differently, materially) determined and therefore subject to restructuring according to a unitary artistic plan. By its own internal logic, the artistic project becomes aesthetico-political. Because there are many artists and projects and only one can be realized, a choice must be made; this decision is in turn not merely artistic but political, since the entire organization of social life is dependent upon it. Consequently, in the early years of Soviet power the avant-garde not only aspired to the political realization of its artistic projects on the practical level, but also formulated a specific type of aesthetico-political discourse in which each decision bearing on the artistic construction of the work of art is interpreted as a political decision, and, conversely, each political decision is interpreted according to its aesthetic consequences. It was this type of discourse that subsequently became predominant and in fact led to the destruction of the avant-garde itself.

When Rodchenko and his group proposed the new program of constructivism[14] in 1919, however, enthusiasm was still overwhelming, and the avant-garde was convinced that

the future was in its hands. Thoroughly renouncing the contemplativeness that to some extent could still be found among the first generation of the avant-garde, Rodchenko, Tatlin, and other constructivists proclaimed the work of art to be a self-sufficient autonomous thing with no mimetic relationship to external reality. The model for the constructivist work of art became the machine, which moved according to its own laws. True, in contrast to the industrial machine, the "artistic machine" of the constructivists was, in the beginning, at least, not regarded as utilitarian. In accordance with their original formalist aesthetics, it was instead meant to bring out the very material of construction and the constructive nature of the machine itself—the "machine of the subconscious," so to speak—that was concealed in the utilitarian machine much as it was latent in the traditional painting that attempted to transmit "conscious" content. The constructivists themselves regarded their constructions not as self-sufficient works of art, but as models of a new world, a laboratory for developing a unitary plan for conquering the material that was the world. Hence their love of heterogeneous materials and the great variety of their projects, which embraced the most diverse aspects of human activity and attempted to unify them according to a single artistic principle.

The constructivists were convinced that it was they and they alone who were destined to undertake the aesthetico-political organization of the country, for although they cooperated with the Bolsheviks politically they were, at bottom, sure of their own intellectual superiority. Initially they regarded the Bolsheviks as merely a necessary transitional phase, a force that could destroy the old world and harness the country to the creation of the new. For their part, the Bolsheviks did not conceal the fact that they had but a vague idea of how to go about this construction, as no specific methods had as yet been developed by Marxist theory. Attempting to secure the broadest possible support from the old intelligentsia, the party, in particular Minister of Culture Anatolii Lunacharskii, was at this time advocating pluralism among artistic currents,

and the party leaders, who had been brought up on traditional aesthetics, were more than mildly skeptical toward the new avant-garde art. Lenin candidly admitted that he understood little about art, but that he did like Beethoven's "Apassionata Sonata," Chernyshevskii's novel *What Is to Be Done?*, and the Revolutionary song, "You Fell the Victims. . . ." The Bolsheviks, of course, appreciated the support of the avant-garde, but they were troubled by its dictatorial ambitions, which repulsed the representatives of other currents that were closer to them aesthetically although usually opposed to them politically. The avant-gardists took this ambivalence on the part of the party as a de facto admission that it was unable to cope with the construction of the new world. They constantly expounded the intimate interrelationship of politics and aesthetics, impressing upon the party the complete opposition between the two currents in art—on the one hand, bourgeois, traditional, counterrevolutionary mimetic art; on the other, the new proletarian revolutionary aesthetics proposing that communism be built as a total work of art that would organize life itself according to a unitary plan.

More and more insistently, the artists, poets, writers, and journalists of the avant-garde merged aesthetic and political accusations, openly calling upon the state to repress their opponents. However, as the stability of the Soviet regime became increasingly obvious and broad circles among the initially hostile intelligentsia began to support the Bolsheviks—which, of course, the latter welcomed—the avant-garde's base began to shrink steadily. The very first years of the New Economic Policy (NEP) witnessed the emergence of a new art market and a new reader demand among the nascent Nepman bourgeoisie, to whom the avant-garde was alien aesthetically and especially politically. The NEP—that of 1922 rather than the 1930s—marks the beginning of the decline of the avant-garde, which, although it continued to exist on a modest scale, had lost all its influence by the late 1920s. Emerging now were such organizations as AKhRR (The Association of Artists for a Revolutionary Russia) and RAPP (The Russian Association

of Proletarian Writers), which combined traditional aesthetic devices and the slogan "learn from the classics" with avant-garde rhetoric and the tactic of labeling their opponents political counterrevolutionaries, a practice that found increasing official support. During this same period there also arose groups of rather influential fellow-traveler artists and writers, many of whom—particularly in groups like OST (Society of Easel Painters) and Bytie (Objective Reality)—in the visual arts were quite young. These artists were not easily intimidated by the avant-garde's incantations, and in their search for a new market for their works they attempted to combine traditional and avant-garde devices within the conventional form of the easel painting.

Significantly, however, it was precisely during this period that the most active radical wing of the avant-garde, the Lef group, associated with the journals *Lef* and then *Novyi Lef*, radicalized its program even more, moving beyond the slogan of constructivism to that of "productionism," that is, the production of utilitarian objects and the organization of production and everyday life by artistic methods. The *Lef* theoreticians declared all autonomous artistic activity to be reactionary and even counterrevolutionary. Rodchenko, who became the leading artist of Lef, called his former ally Tatlin a "typical Russian holy fool" for his loyalty to the "mystique of the material." When Tatlin designed his famous utopian Monument to the Third International and for the first time a Bolshevist note began to creep into the avant-garde debate, Shklovskii objected with a call for purity, universalism, and the rejection of political commitment. He was answered that Communist power, the Third International, and so forth were as much a fantasy as the art of the avant-garde and could therefore be considered avant-garde materials and used as elements in avant-garde constructions.[15] Constructivist theoretician Aleksei Gan declared:

> We should not reflect, depict and interpret reality, but should build practically and express the planned objectives of the newly active working class, the proletariat . . . the master of

color and line . . . the organizer of mass actions—must all become Constructivists in the general business of the building and the movement of the many millioned human mass.[16]

Although in the 1920s the polemics of *Lef* and its artistic position became even more radical than this initial optimism, they also reflect the avant-garde's wavering confidence in its ability to accomplish its goals on its own. Lef's language gradually became more "Communistic," and the group itself was increasingly inclined to view the party as the only force capable of implementing its projects. More and more, it regarded itself as a "specialist" working to fulfill the "social commissions" of the party and as an artistic mentor whose duty was to identify true friends and foes and teach the party to formulate constructive artistic tasks in response to the demands of the time.

Boris Arvatov is an illustrative example. A leading theoretician of "productionist" Lef, Arvatov was a former Proletkultist who had been influenced by Bogdanov's "general organizational science," which Proletkult thought of as a Marxist replacement of contemplative knowledge of the laws governing the world by the concrete organization of the world on a new basis. Although Arvatov maintains that artists should organize the life of society down to the smallest everyday details to give the world a new artistic form corresponding to the contemporary level of technological progress—that is, to bring it into harmony with progress (here again that same old idea of Malevich's)—at the same time he limits the role of art to the search for the optimal means of achieving total organization, whose goals should come from without. "Artists," Arvatov writes, "must become the colleagues of scholars, engineers, and administrators."[17] Thus he continues to perceive the goal of art to be the creation of a closed, autonomous, internally organized, self-contained whole that does not refer to anything outside itself, except, perhaps, in the functional sense; that is, Arvatov's notion of the work of art continues to tend toward the traditional avant-garde ideal of the internal combustion engine into which he would like to transform all

of society. In Arvatov's theory, however, this ideal has already lost the universal cosmic dimension typical of Malevich's and Khlebnikov's avant-garde and is instead restricted to the purely social reality controlled by concrete political forces. The main burden of organizational work is transferred to these forces—specifically, the Communist party—and all that remains for the artist is to fulfill limited functions within the framework established by the unitary "party command." Proceeding here from its own artistic project, the avant-garde itself renounces its right of preeminence and surrenders the project to the real political power, which is beginning to take over the avant-garde artist's task of drawing up the unitary plan of the new reality. The demand for complete political power that follows from the avant-garde artistic project is in effect now supplanted by the demand that the real political power acknowledge that its project is aesthetic in nature.

Arvatov's view of traditional mimetic art is marked by the same dualism. On the one hand, he declares this art a feature of an imperfectly organized society, that is, the result of a failure and an obstacle to the avant-garde project—a morbid phenomenon that testifies to the insufficiently "artistic" character of life itself. He rejects the "contemplative" art of Malevich, Kandinskii and Tatlin on the same grounds. Arvatov writes approvingly of the role of left art in the early years of the Revolution: "The mask of realism concealed the blackest reactionary desires; the high priests of eternal art who sympathized with the Kadets persecuted everyone else. They had to be destroyed, driven out, disarmed."[18] Arvatov is also negative toward the 1920s renaissance in the visual arts, which he interprets in the usual leftist way as a symptom of the overall cultural reaction associated with NEP. On the other hand, the function he is prepared to allot to art is not only constructive and organizational but also agitational, since in such a role art does not simply reflect life but really contributes to transforming it. For this task he is obliged to rehabilitate even the traditional mimetic "easel painting" that was theoretically destroyed by productivism: "Figurative art as an art of fantasy

can be considered justified when for its creators and for society as a whole it serves as a preliminary step in the transformation of all society."[19] Obviously, this formulation anticipates later aesthetic tenets of the Stalin period.

The other leading theoreticians of Lef held similar views. In an article by Nikolai Chuzhak characteristically entitled "Under the Sign of Life-Building"—an obvious allusion to Vladimir Solov'ev[20]—we read: "Art as a method of knowing life . . . is the highest content of the old bourgeois esthetics. Art as a method for building life—this is the slogan behind the proletarian conception of the science of art."[21] The allusion to Solov'ev, of course, prevents Chuzhak's position from being considered exclusively or completely "proletarian." Following Hegel, Solov'ev maintained that the cognitive role of art had ended and that art must therefore be assigned a new goal—the transformation of reality—if it was to be granted continued legitimacy. According to Solov'ev, the artist must cease to be defined by "inherited religious ideas"—that is, cease creating within a tradition—and instead strive for the "conscious control of the incarnations of the religious idea" that were supposed to reveal things in their future aspect. Only then will the artist become truly "popular" [vsenaroden]; that is, rather than subscribing to popular conceptions of the aspect of things as they are, he will show to everyone things as they will be at the end of time.[22]

The reduction of this new function of art—with which Chuzhak essentially agrees—to the "proletarian science of art" amounts once again to a capitulation to the leading role of the party. The life-building artist becomes in effect a mere "decorator" of a reality created by someone else, a role to which Chuzhak himself vehemently objects. It was not for nothing that the AkhRR opponents of Lef maintained that its program was not so very different from that of any Western artist employed by a large corporation as a designer, in advertising, and so on.[23] Chuzhak's own awareness of this contradiction probably accounts for the following famous passage in the above article:

> We imagine a moment when real life saturated to overflowing with art will *reject* art as unnecessary; this moment will be a blessing to the futurist artist, his beautiful "go in peace." Until then, the artist is a *soldier* guarding the social and socialist revolution as he awaits the great "corporal of the guard"—Halt![24]

Here we no longer deal with the disappearance of art as an autonomous sphere of activity, as in the initial premise of the avant-garde as a whole, but with a renunciation of avant-garde art itself, a rejection of the artist in his or her extreme productionist embodiment. The avant-gardist here is not the heroic creator of a new world, but a stoic dedicated to a doomed cause. It is not, as in Hegel, science and the Idea that overcome art in its cognitive function, nor is the artist replaced by the thinker. Rather, it is in precisely this new, avant-garde function of constructor of the new world that the artist is succeeded by a military and political leader ruling over the whole of "reality saturated with art"—the mystical figure of that "great corporal of the guard" soon to be incarnated in the very real figure of Stalin. Here Chuzhak points to the inherent limit of the avant-garde artistic project. If the limitations of the mimetic art claiming to provide knowledge of reality were marked by science, which successfully accomplished that project, then the limitations of the life-builders' project of total mobilization in the name of beautiful form were marked by military and political power, which not only theorized about mobilization but mobilized in actual fact.

Lef's theory was in complete agreement with its artistic practice. Since its artists and writers could not directly influence production or determine real social relations, they concentrated above all on agitation and propaganda. Maiakovskii designed his famous "windows" for ROSTA (the official information agency) and wrote advertisements; Rodchenko painted posters, and many others designed theater sets, clubs, and so on. The avant-garde art in such projects became increasingly figurative, although the artists strove to work with the photograph rather than the easel painting, and the writers aspired toward so-called literature of fact, that is, newspaper

materials rather than traditional narrative forms. Newspaper reports on the "victories of labor" or photographs of smiling collective farmers and proletarians with their faces turned to the future may have been interpreted as "facts" and contrasted with the "fictive," "illusory" art of the past; but to the modern observer, at least, a glance at Lef's agitational art reveals that the material with which the group was working was not any immediate manifestation of "life" but the product of manipulation and simulation by mass media under the complete control of the party propaganda apparatus. All of these newspaper materials and photographs dedicated to "topical themes," "public statements by front-rank workers," and similar Soviet ideological products modeled on stereotypes patterned in turn on the idealized hagiographic art of the past were interpreted by Lef as materials of life itself—materials which, although they must be shaped creatively, were raw and primary outside this process. The Achilles' heel of avant-garde aesthetics as a whole lies in this failure to understand the mechanisms through which reality is technically processed by the modern means of communication that register it. In part because the artists of *Lef* enthusiastically shared the underlying ideology and were actively involved in this processing, in both theory and practice they regarded the photograph and the news article as a means for discovering reality and remained blind to the fact that such forms of information are an ideological operation.

The Lef ideologists, therefore, looked down with scorn on the "uncultured," "reactionary" AKhRR, which simply illustrated party decrees with traditional paintings or created "tendentious art" that claimed no independent aesthetic function. The members of Lef regarded themselves in the spirit of Solov'ev as "engineers of the world" who overcame the opposition between autonomous and utilitarian art by subordinating their works to a single universal purpose that deprived art of its autonomy only in the name of something higher than any temporal goal, namely, the transformation of the world as a whole. From the perspective of this synthesis, the art of AKhRR really is a kind of "antisynthesis"—an awkward com-

bination of traditional autonomous figurative art and subordination to the crude utilitarian aims of propagating and illustrating the latest party proclamations. The members of Lef considered that it was they instead who were called upon to shape the life and consciousness of the masses through the "incarnations" of the new Communist religion.

Despite all their daring experiments with newspaper and advertisement language (Maiakovskii) or the photographic image (Rodchenko), however, Lef's art was rendered secondary by the fact that it was unconsciously dependent on the ideological processing of primary visual and verbal information. Neither the newspaper nor the photograph was questioned as media; in Lef-Opoiaz terminology, therefore, the sincerity of the "servile" illustrations of AKhRR allows them to be regarded as a "laying bare of the device." In other words, such works revealed the secondary nature of art—including that of Lef—relative to ideology and its immediate manifestations in the form of party decrees, instructions, and theses.

The blindness of the avant-garde in this respect isolated it and led to its dual defeat in the late 1920s. On the one hand, as the state consolidated its power, Lef's aspirations to engage in autonomous life-building distinct from the actual party-led construction of socialism became increasingly anachronistic, inappropriate, and irritating; on the other hand, the moderate "fellow-traveler opposition" that in many respects set the tone in the 1920s was, within the bounds set by the censorship, attempting to use traditional mimetic means to create an image of reality that to some extent diverged from the official one. This fellow-traveler intelligentsia therefore regarded the apologetic art of the avant-garde as totally unacceptable and even dangerous, since in those harsh years avant-gardist accusations of "counterrevolutionary form and content" could represent a mortal threat.

It deserves to be noted that Soviet attitudes toward the avant-garde continue even today to reflect its dual isolation from both the state and the opposition. In the context of the Western museum, the Russian avant-garde may be highly re-

garded as one original artistic phenomenon among others, but in the Soviet Union its claims to exclusiveness and its almost realized ambitions to destroy traditional cultural values have not been forgotten. The vindictive state still cannot forgive the avant-garde for competing for the leadership of the transformation of the country, and the no less vindictive opposition cannot forgive it for persecuting its "realist" opponents. Aside from a few enthusiasts gravitating toward the West and Western scholarly notions, therefore, even today the resurrection of the avant-garde is universally regarded as unnecessary and undesirable. Bulgakov, Akhmatova, Pasternak, and Mandel'shtam, all of whom contrasted their traditional conception of the writer to the new propaganda apparatus, are being canonized everywhere, but Lef is usually remembered as a shameful disease that has fortunately been cured and is best not mentioned in public. History teaches us that this situation may and even probably will change, but it is at present impossible to predict when and how that might happen.

The fears Malevich expressed to the constructivists in many of his later writings generally came to pass: the quest for "perfection" through technology and agitation made them prisoners of the time and led them into a blind alley, since such a search is equivalent to the founding of a new church, and since all churches are ephemeral and doomed to extinction when faith in them disappears.[25] As to his own art, Malevich assumed on the contrary that, because it arose out of nothing—out of the all-negating material infinity and nonobjectivity of the world—it transcended all beliefs and ideologies. Yet the very name of his artistic principle—"suprematism," or the doctrine of the highest—indicates that he himself was not free of the idea of "perfection" for which he reproached others. He himself programmed the defeat of the avant-garde when he made the artist a ruler and demiurge rather than an observer. For Malevich as for Khlebnikov, of course, contemplation and domination still constitute a unity; they still contain a living faith in the magic of the image and the word, which, like Plato's "Idea" or the "Truth" of the seventeenth-century rationalists, would the moment they appeared peaceably subdue

entire peoples and grant absolute power over the enchanted world. In this sense Malevich's position is truly "supreme," for it marks the greatest possible faith of the creator in his creation. This high point, however, was soon passed, and "restructuring of the old life" began to be forced upon those who were prevented by the "remnants of the past" in their thought from absorbing the truth of the new mystical revelations. Before the people could gain access to the supreme truths of the new ideology, their consciousness would have to be transformed through changes in the base, the subconscious, and the conditions of existence.

THE STALINIST ART OF LIVING

THE AVANT-GARDE as an independent entity was forever rendered impossible by the Central Committee decree of April 23, 1932, which disbanded all artistic groups and declared that all Soviet "creative workers" would be organized according to profession in unitary "creative unions" of artists, architects, and so on. This party decree, which was intended to put an end to factional strife "on the artistic and cultural front" and subordinate all cultural activity to the party leadership, formally marks the beginning of the new, Stalinist phase in Soviet culture. It was adopted during the first "Stalinist" five-year plan, whose goals included accelerated industrialization guided by a single, rigorously centralized plan, a program of forced collectivization that can be regarded as the second, Stalinist revolution, the liquidation of NEP and its relative economic freedoms, and the suppression of opposition within the party, which was accompanied by a rapid increase in the influence of the security organs. To achieve Stalin's objectives of "socialism in one country" and the "total restructuring of life" after the party's "tactical retreat" during NEP, the regime now launched an energetic program for gaining total control over even the most trivial aspects of everyday existence.

The termination of NEP also meant that the private art market was liquidated and that all "detachments on the Soviet art front" began devoting their energies to filling party orders. In effect, all culture became, in Lenin's famous phrase, "part of the common cause of the party,"[1] which in this case meant a means of mobilizing the Soviet population to fulfill the party's restructuring directives. Lef leader Maiakovskii was thus granted his wish that the government analyze his poetry together with other achievements on "the labor front." The

pen, as he had hoped, had become the equal of the bayonet; like any other Soviet enterprise, the poet could now report to the party, "raising high the hundred volumes of his party books," and through the monument "to us all, . . . socialism was being built in struggle." The avant-garde's dream of placing all art under direct party control to implement its program of life-building (that is, "socialism in one country" as the true and consummate work of collective art) had now come true. The author of this program, however, was not Rodchenko or Maiakovskii, but Stalin, whose political power made him the heir to their artistic project. As noted earlier, the avant-garde was itself prepared for such a development and stood stoically awaiting the great "corporal of the guard." The central issue to these artists was the unitary nature of the politico-aesthetic project rather than whether such unity would be achieved by politicizing aesthetics or aestheticizing politics, especially since it could be maintained that the aestheticization of politics was merely the party's reaction to the avant-garde's politicization of aesthetics. Although the party had long attempted to observe a certain neutrality in the struggle among various artistic groups, their internecine strife had literally forced it to intervene.

One significant result of this prolonged strategy of neutrality was that most of the creative intelligentsia warmly welcomed the 1932 decree stripping the power from influential organizations such as RAPP and AKhRR, which by the late 1920s and early 1930s had established a virtual monopoly in culture and were persecuting all political undesirables. It was not Stalin but RAPP and AKhRR that in fact liquidated the avant-garde as an active artistic force. The symbol of this defeat was the suicide of Maiakovskii, who had just joined RAPP in order at least partially to escape persecution and who was subsequently proclaimed by Stalin to be "the best poet of the Soviet era." Many fellow-travelers close to the avant-garde became prominent writers under Stalin: Shklovskii, Tynianov, Pasternak, and others were published, as were Kaverin (a former Serapion Brother), and Ehrenburg (who together with Lisitskii had published the constructivist journal

Veshch' [*Thing*] in Berlin). There were also more conservative
fellow-travelers who had been blocked by RAPP and now
went on to successful careers. Stalin, therefore, really did to
some extent justify the hopes of those who thought that direct
party control would be more tolerant than the power exer-
cised by individual groups of artists. It was once rather aptly
said of Stalin that he was a typical politician of the golden
mean, except that whatever he found extreme he destroyed.
Responding to the prolonged entreaties of the majority of So-
viet artists and writers to take direct control of culture, Stalin
presented his own project, and he was prepared to welcome
anyone from any camp who unconditionally supported it.
Those who insisted on their own exclusiveness or emphasized
past services, on the other hand, were regarded as attempting
to be "wiser than the party," that is, the Leader, and were
ruthlessly punished. The result, which often surprised outside
observers, was that the most ardent supporters of the party
line became Stalin's first victims. It was no accident, therefore,
that the triumph of the avant-garde project in the early 1930s
should have coincided with the final defeat of the avant-garde
as an established artistic movement. There would have been
no need to suppress the avant-garde if its black squares and
transrational poetry had confined themselves to artistic space,
but the fact that it was persecuted indicates that it was operat-
ing on the same territory as the state.

In accordance with the rules prescribed by the art of war,
Stalin's aesthetico-political coup was preceded by a series of
conferences whose participants included not only Stalin, but
also high-ranking party and government leaders close to him,
such as Molotov, Voroshilov, and Kaganovich, and a number
of writers, most of whom were later shot (Kirshon, Afino-
genov, Iasenskii, and others).[2] Henceforth, just as Maiakov-
skii had demanded, the speeches of party leaders on the state
of the country would juxtapose analyses of agriculture, indus-
try, politics, and defense with comments on the situation in art
that attempted to define "realism" and the desirable relation-
ship between form and content, discussed the problem of the
typical, and so on. It is of course irrelevant to object here that

Voroshilov or Kaganovich or Stalin himself were not experts on literature or art, for they were in reality creating the only permitted work of art—socialism—and they were moreover the only critics of their own work. Because they were connoisseurs of the only necessary poetics and genre—the poetics of the demiurgic construction of the new world—they were as entitled to issue orders on the production of novels and sculptures as they were to direct the smelting of steel or the planting of beets.

Stalin approved the slogan "socialist realism" and proclaimed it mandatory for all Soviet art. Most important here was literature—the socialist realist method was given its final form and adopted at the First Congress of the Writers' Union in 1934, and was subsequently superimposed on the other arts with no alterations whatever. This alone is evidence of its "antiformalist" spirit, which was oriented not toward the specific characteristics of a given art form, but toward its "socialist content," and it is for this reason that socialist realism is usually interpreted as the absolute antithesis of the formalist avant-garde. The discussion below, however, will focus on its continuity with the avant-garde project, even though the realization of that project differed from the avant-garde vision. The basic line of this continuity has already been sketched in some detail above: the Stalin era satisfied the fundamental avant-garde demand that art cease representing life and begin transforming it by means of a total aesthetico-political project. Thus if Stalin is viewed as the artist-tyrant who succeeded the philosopher-tyrant typical of the age of contemplative, mimetic thought, Stalinist poetics is the immediate heir to constructivist poetics. Still, there are obvious formal differences between socialist realism and avant-garde art, and, as has already been noted, these must be explained on the basis of the logic of the avant-garde project itself rather than as the result of attendant circumstances such as the low cultural level of the masses or the personal tastes of the leaders. Such factors were present, of course, and to some extent they have always existed everywhere—both in the West and in the East—yet in the conditions created by Stalinist culture they behave quite dif-

ferently. It must not be thought, therefore, that they clarify anything about the specific situation of the time. The avant-garde regarded the plurality of tastes upon which the art market depended as analogous with the parliamentary democracy that the Bolsheviks had replaced: the tastes of the masses and the new reality were to be shaped together. Sergei Tret'iakov, noting that the complete restructuring of everyday life must focus first of all on remaking the human beings defined by this life, declared:

> Propaganda about forging the new human being is essentially the only content of the works of the Futurists, who without this leading idea invariably turn into verbal acrobats ... what guided Futurism from the days of its infancy was not the creation of new paintings, verses, and prose, but the production of a new human being through art, which is one of the tools of such production.[3]

As is evident from Stalin's "shifted" avant-garde metaphor "writers are the engineers of human souls," Stalinist aesthetic theory and practice proceed from this same conception of educating and shaping the masses.

Simplifying somewhat, we can group the basic differences between avant-garde and socialist realist aesthetics around the following problems: (1) the classical heritage; (2) the role of reflecting reality in the shaping of reality; and (3) the new individual. Below I shall argue that the relevant distinctions arose not because the avant-garde project was abandoned, but because it underwent a radicalization that the avant-garde itself was unable to accomplish.

JUDGMENT DAY FOR WORLD CULTURE

The attitude of the Bolshevik leaders toward the bourgeois heritage and world culture in general can be summarized as follows: take from this heritage that which is "best" and "useful to the proletariat" and use it in the socialist revolution and the construction of the new world. Whatever their differences in other respects, on this point all Bolshevik ideologists

agreed. Lenin sneered at Proletkult's attempts to create its own, purely proletarian culture,[4] but even Bogdanov, whose theories were the basis for Proletkultist activity, called for the past to be used in approximately the same terms as Lenin.[5] Although Trotsky and especially Lunacharskii were more sympathetic than other leaders toward "left" art, their appreciation of traditional cultural forms was never shaken by avant-garde propaganda.

Although the party leaders' positive attitude toward the classical heritage was a source of later Stalinist definitions of socialist realism, it must not be confused with the devotion to the classics displayed by groups hostile to the Soviet regime or by fellow-traveler ideologues such as Polonskii, Voronskii, or even Georg Lukacs, all of whom were rejected by Stalinist culture.[6] The turn of the opposition and fellow-travelers to the classics was motivated by an aspiration to defend the traditional role of the autonomous artist who maintained an aesthetic distance to reality and was therefore capable of independently observing and recording it. Such a role suited neither the avant-garde nor the party, and there was no place for it in Stalinist culture. The artist's involvement in the shaping of reality within a unitary, collectively executed project precluded "disinterested" contemplation, which under the prevailing circumstances was invariably regarded as tantamount to counterrevolutionary activity.

The issue in the debate between the avant-garde and the party was not whether or not art should be totally utilized—on this point both sides were in agreement—but concerned the scope of the artistic means and resources subject to such utilization. The stumbling block here was avant-garde reductionism, which if implemented would first of all deprive the party of the means of influencing the individual and society available in classical art; and second and even worse, it would in effect leave all traditional art, which at that time also represented considerable material wealth, in the complete control of the bourgeoisie. This latter fact ran directly counter to the tactics of the Bolsheviks, who wanted to "seize the cultural heritage from the bourgeoisie and give it to the proletariat,"

or, what amounts to the same thing, to appropriate it for themselves as they had already done with the state apparatus, the land, and the means of production.

From the very outset, the party was particularly critical of the avant-garde program for artificially and illegitimately limiting the use of the property that had been seized from the former ruling classes. When, to cite the two most frequently quoted declarations of the time, the futurists urged that Pushkin be "cast overboard from the steamship of modernity" and the Proletkult poets proclaimed they would "burn Raphael and trample the flowers of art in the name of our tomorrow," the party regarded such summons as incitements to destroy state property, which, in the case of Raphael, for example, could be sold for a great deal of money or at least be used to nurture "the feeling of harmony absolutely necessary to any builder of the radiant future." The charge most commonly leveled against the avant-garde was that they were "liquidationists" and thus Mensheviks, and at the same time left revisionists. The avant-garde struggle with past art was interpreted as a call to "liquidate" it and "to squander our ideological arsenal." The party's goal, on the other hand, was not to deprive itself of the tried weapon of the classics, but on the contrary to give it a new function and use it in the construction of the new world. Here the avant-garde encountered its own limitation: although it denied the criteria of taste and artistic individuality in the name of the collective goal, it continued to advocate singularity, individuality, and purely subjective taste as justification for its own devices. Almost from the very birth of the avant-garde, this contradiction was pointed out by certain of its most radical representatives, in particular the so-called vseki,[7] who insisted on a consistent eclecticism and maintained that the avant-garde's search for an original "modern" style artificially narrowed the scope of its project.

If the avant-garde and its adherents looked upon socialist realism as a kind of artistic reaction and "lapse into barbarism," it must not be forgotten that socialist realism regarded itself as the savior that would deliver Russia from barbarism by preserving the classical heritage and all of Russian culture

from the ruin into which the avant-garde wanted to plunge it. Unbelievable as it may seem today to anyone who views avant-garde works in a museum but forgets that the avant-garde project did not allow for the existence of either museums or works, it was perhaps this role of savior of which the theoreticians of socialist realism were most proud. This pride is clearly perceptible many years later in the once universally quoted passage from a speech by Andrei Zhdanov:

> At one time, as you know, bourgeois influences were very strong in painting. They cropped up time and again under the most "leftist" flags, giving themselves such tags as futurism, cubism, modernism; "stagnant academicism" was "overthrown," and novelty proclaimed. This novelty expressed itself in insane carryings-on: for instance, a girl was depicted with one head on forty legs, with one eye turned toward us, and the other toward the North Pole.
>
> How did all this end? In the complete crash of the "new trend." The Communist Party fully restored the significance of the classical heritage of Repin, Briullov, Vereshchagin, Vasnetsov, and Surikov. Were we right in reinstating the treasures of classical painting, and routing the liquidators of painting?
>
> Would not the continued existence of such "schools" have meant the nullification of painting? Did the Central Committee act "conservatively," was it under the influence of "traditionalism," of "epigonism" and so on, when it defended the classical heritage in painting? This is sheer nonsense!
>
> . . . We Bolsheviks do not reject the cultural heritage. On the contrary, we are critically assimilating the cultural heritage of all nations and all times in order to choose from it all that can inspire the working people of Soviet society to great exploits in labor, science, and culture.[8]

Thus Zhdanov finds absurd the very thought that he might be accused of traditionalism, and in fact it was he who launched the persecution of the traditionalist writers Akhmatova and Zoshchenko. It is, on the contrary, the avant-garde's position that Zhdanov presents as backward and obsolete. This motif of the absolute novelty of socialist realism relative

to all "bourgeois" culture, including the avant-garde, surfaces constantly in the writings of the apologists of Stalinist culture, who refused to regard themselves as "reactionaries." In this respect as well we can truly agree with them. The avant-garde proclaims that an entirely new era in art is succeeding the age of the representational easel painting, yet by regarding its own works in contrast to traditional ones it assumes a place in the history of art that it has declared to be terminated as of its own appearance. Avant-garde reductionism arises out of the aspiration to reject tradition and begin from zero, but this very rejection is meaningful only insofar as tradition is still alive and serves as its background. The formal innovations of the avant-garde, therefore, internally contradict the requirement that all autonomous forms be rejected. This contradiction is resolved by the productionist demand that easel painting, sculpture, narrative literature, and so forth in general be abandoned, but it is obvious that this demand remains a gesture within that same historical continuity of styles and artistic problems. Thus because the avant-garde cannot abandon its opposition to tradition, it becomes a prisoner of the very tradition it wants to overthrow.

To the Bolshevik ideologists, in contrast, point zero was the ultimate reality. The art of the past was not living history that could serve as a guide to the present, but a storehouse of inert things from among which anything that seemed appealing or useful could be removed at will. It was often said in Stalin's time that the Soviet Union was the sole preserver of the cultural heritage that the bourgeoisie itself had rejected and betrayed. Stalinist theoreticians found confirmation of the fact in the success of the "nihilist" and "antihumanist" avant-garde in the West. The absolute novelty of socialist realism needed no external, formal proof, for it followed from "the absolute novelty of the Soviet socialist order and the party agenda." Thus the novelty of Soviet art derived from the novelty of its content rather than from any "bourgeois" novelty of form, which merely concealed an old, "bourgeois" content. In its own view, Stalinist culture was not merely culture in the making, but represented instead the mature, posthistorical culture

for which the "capitalist encirclement" was simply an external, moribund formation fated to disappear together with the entire "history of the class struggle." To such a thoroughly apocalyptic consciousness the whole question of original artistic form seems impossibly antiquated. The relationship between Stalinist culture and the avant-garde is similar to that between the established church and the first ascetic sects: in both cases the blessings of the old world were first renounced and then, after the victory, exploited and "sanctified" in the new age.

The relationship of Stalinist culture to the classical artistic heritage conforms to its relations with tradition in general. The so-called Stalin Constitution of the 1930s resurrected the basic civil liberties; elections were held regularly, and even many minor details of the former way of life were revived—epaulets were reintroduced in the army, for example, as was the old aristocratic model of separate schools for boys and girls. All of these reforms were at first hailed by liberal observers as symptoms of "normalization" after the nihilism of the early revolutionary years. In actual fact, of course, the Stalinist ideologists were far more radical than the cultural revolutionaries, who had received a very bourgeois upbringing and who were in fact Westernizers aspiring to make Russia a kind of better America. The radicalism of Stalinism is most apparent in the fact that it was prepared to exploit the previous forms of life and culture, whereas even the avant-garde detractors of the past knew and respected the heritage to such a degree that they would rather destroy than utilize or profane it. (Just how smoothly the mechanisms of Stalinist culture worked can be seen in the denunciation at about this time of the prominent constructivist mathematician Nikolai Luzin. Luzin was accused of taking "a Menshevik and Trotskyist position in mathematics, as is apparent in his intention to deprive the proletariat of the important weapon of transfinite induction." Transfinite induction was repudiated by constructivist mathematics, which, although it arose at about the same time as artistic constructivism, is entirely unrelated.)

Attitudes toward the classical heritage may also be regarded from another perspective. The art of the avant-garde

was theoretically based on the method of "making it strange" or "laying bare the device," techniques that were supposed to reveal the mechanisms by which the work achieved its effects. This method also assumed continuity in the history of art, as it described each successive current as a baring of the devices concealed by its predecessors. Thus Malevich's suprematism can be viewed as working with the color and pure form that had been hidden by the mimetic forms or "content" of the traditional representational painting; Khlebnikov's verbal artistry reveals a phonetic side of speech that was hidden in classical "content" poetry, and so on. This theory demanded that art constantly be renewed and "made strange" to produce an unusual quality, novelty, and "shift" that would enhance its impact on the viewer. It might even be said that the politics of the revolutionary years were another such baring of the device. Thus it was maintained that liberal democracy is inherently repressive but conceals its repressiveness behind its form, and that this oppression must therefore be revealed by means of open proletarian terror, which, precisely because it is so candid, is superior to bourgeois democracy.

Obviously, this theory presupposes a background that can be shifted, negated, made strange. It proceeds upon the notion that the receptivity of the viewer is gradually blunted and therefore in need of renewal. Yet it was "the baring of the device" and novelty as such to which spectators of the 1920s and 1930s were no longer responding—what they wanted, as it were, was for the device to be concealed. The theory of the "bared device" contains the contradictory demands that the human subconscious be mastered and manipulated as by an engineer, on the one hand, and, on the other, that this manipulation and the achievement of the effect be revealed on the level of conscious perception. Thus formalist aesthetics required art to shape reality and then, in a spirit of "permanent revolution," immediately to destroy what it had shaped in order to comply with the demand for constant novelty. This in fact precluded the systematic, planned work that was declared to be the artistic ideal.

Stalinist culture, in contrast, was most interested in various means by which the subconscious could be shaped without

revealing the mechanisms of the process. Such, for example, were Pavlov's theory of conditioned reflexes or Stanislavskii's "Method," which taught actors to enter into their roles so completely as to lose their own identities. Stalinist culture strove not to deautomatize but rather to automatize consciousness, to shape it in the desired mold by controlling its environment, its base, its subconscious, which did not imply that the relevant devices were somehow "ideologically" concealed on the level of theoretical interpretation. Consequently, what the solution of this problem presupposed was not the rejection of artistic techniques in order to bare their devices (which theoretically produced an emotional shock but in fact merely neutralized their effect) but, on the contrary, a study of these devices and their purposeful application. Viewed from the perspective of the avant-garde's theoretical self-interpretation, in other words, Stalinist culture both radicalizes and formally overcomes the avant-garde; it is, so to speak, a laying bare of the avant-garde device and not merely a negation of it.

Of particular interest in this context is the prominent formalist theoretician Grigorii Vinokur's article "On Revolutionary Phraseology," which appeared in an early issue of *Lef*. Vinokur objects to the monotony of official Soviet propaganda, which he says has rendered it completely ineffective. Although he admits that the Soviet strategy of drumming the same simple slogans into the popular consciousness has been successful, in the best formalist tradition he fears that if used forever the approach will produce the opposite result and automatize the impact of the slogans. In other words, they will merely "go in one ear and out the other," and will never be consciously perceived by the masses. Almost pleading for mercy he continues: "Strike once, strike twice, but don't beat them unconscious!"[9] Even staunch Communists are no longer receptive to typical Soviet slogans such as "Long live the working class and its vanguard the Russian Communist party!" or "Long live the victory of the Indian workers and peasants!" for these are mere "hackneyed clichés, worn copper farthings, worthless tokens . . . a transrational language, a collection of sounds to which our ear has become so accus-

tomed that it is utterly impossible to react to these exhortations."[10]

This last remark warrants caution, however, for in an earlier essay[11] Vinokur praises Khlebnikov's transrational poetry and suggests that transrational language offers the means of consciously and systematically controlling language as such. When toward the end of his article on revolutionary phraseology, therefore, he urges recourse to poetry—by which he undoubtedly means especially futurist poetry—one cannot help but wonder just why one form of transrational language should be exchanged for another.

Khlebnikov began creating his transrational language at a time when the Russian linguistic subconscious was starting to disintegrate. This is the source of his project for a new, magic discourse that would reunite all speakers beyond the bounds of ordinary "rational" language, in which the conflict of opinions, styles, and slogans had done irreparable damage and led to the irreversible decline of the previous linguistic unity. In the Soviet period, however, language acquired a new unity, a new linguistic subconscious that had been artificially "drummed in" by the party. The moment they were no longer perceived as such, the party slogans "dominated" the masses, becoming their subconscious, their way of life, the sort of self-evident background that remains imperceptible until it is lost by the emigré abroad. The slogans thus became transrational and ceased to bear any definite content, that is, in the terms of formalist aesthetics they were "formalized" and "aestheticized." The fact that formalist aesthetics could not identify them in this function is evidence of the fundamental weakness shared by the theory and the Russian avant-garde in general. Born in a period when the world and language were in decline and dedicated to the goal of halting and compensating for this disintegration, the avant-garde lost its inherent legitimacy and even its previous powers of analysis when the process was overcome in reality not by it but by its historical rival.

The principal ideological obstacle to the assimilation of the classical heritage was for a long time the notion of so-called vulgar sociologism, which viewed art and culture in general as

a "superstructure" erected on the economic base. This thoroughly orthodox Marxist thesis was widely applied by avantgarde theorists, in particular Arvatov, to substantiate the necessity of creating a specifically proletarian art that was to be formally novel with respect to the art of the past. The usual "fellow-traveler" objection to this demand—that in the 1920s Soviet Russia did not yet have the socialist economic base to which such a new art could correspond—became of course unacceptable in the Stalin era of "socialism in one country."

The solution was found in Lenin's earlier ideological construct of "two cultures in one,"[12] which holds that the culture of a given period does not uniformly reflect the base as a whole but is split into two camps, each of which expresses the interests of the two classes struggling within each economic formation. Thus for each period it can be established which art is progressive, that is, reflects the interests of the oppressed and historically progressive classes of society, and which is reactionary and reflects the ideology of the exploiting classes. On the basis of this theory socialist realism was proclaimed the heir to all progressive art of all periods of world history. As to the reactionary art of each period, it was to be forgotten and stricken from the annals of history; the only possible reason for preserving anything at all was to illustrate the forces hostile to genuine, progressive art.

Thus since socialist realism shared the "historical optimism," "love of the people," "love of life," "genuine humanism," and other positive properties characteristic of all art expressing the interests of the oppressed and progressive classes everywhere in all historical periods, it acquired the right to use any progressive art of the past as a model. Frequently cited examples of such progressive art included Greek antiquity, the Italian Renaissance, and nineteenth-century Russian realism. All oppressed and progressive classes of all ages and nations were united by Stalinist culturology into a single notion of the "people." This meant that both Phidias and Leonardo da Vinci were considered popular artists, since even though they themselves did not belong to the exploited classes, their works objectively expressed the progressive popular ideals of their

time. As stated by an instructive article in *Voprosy filosofii* published in the final period of Stalinist aesthetics, "Great classical art has always been imbued with the spirit of struggle against everything old and obsolete, against the social vices of its time. Herein resides the vital force of truly great art, the reason it lives on even when the age that gave birth to it has long since disappeared."[13]

It is noted further that "classical realist art retains its significance for us because of its links with the people."[14] This, it is observed, is particularly true of the classical Russian heritage. Moreover, it must not be supposed that "proletarian ideology" is the sole guarantee of realism. Most important are the realist method itself and its inherent bond with the people, whose heritage, as Lenin has shown in his discussion of Tolstoi, "contains elements that retain their significance, that belong to the future. It is this heritage that the Russian proletariat assumes and reworks."[15] Although Tolstoi's worldview was by no means Marxist, his heritage is therefore still important. The journal concludes on this basis that the theorists of the 1920s were incorrect when,

> like RAPP, they derived the objective significance of a work directly from the subjectively professed ideology of the artist or writer. . . . The Communist party and its leaders Lenin and Stalin led the struggle against Proletkult, against RAPP, against all the vulgarizers and their anarchist, contemptuous attitudes toward the great cultural achievements of the past. The party unmasked the Machist-Bogdanovite essence of Proletkult and the "theories" of RAPP, which are deeply inimical to the Soviet people. The struggle against anti-Marxist, nihilist views in aesthetics is a part of the party's overall struggle against formalism and naturalism and for socialist realism in art and literature.[16]

In this view, then, all "progressive" world culture acquires a superhistorical significance and eternal relevance that make it the contemporary of any new "progressive" aspiration, and "antipopular," "reactionary," "decadent" culture assumes a no less superhistorical, universal significance that reveals its inner sameness at any given moment of history. As has already

been noted, Stalinist culture looks upon itself as postapocalyptic culture—the final verdict on all human culture has already been passed, and all that was once temporally distinct has become forever simultaneous in the blinding light of the Final Judgment and the ultimate truth revealed in Stalin's *Short Course* of party history. Only that which can endure this radiance will remain to bask in it—everything else will be plunged into a gloom from which only "decadent" moans can be heard.

Between the progressive and the reactionary in each historical period, therefore, Stalinist culture discerns an absolute difference that is usually imperceptible to the formalist eye, which registers only similarities deriving from the unity of a historical style. Thus if Schiller and Goethe are regarded as "progressive" and "popular," Novalis and Holderlin are reactionary, antipopular exponents of the ideology of the moribund feudal classes, and so on. Under Stalin, such reactionary authors usually disappeared from the historical annals no less completely than recently unmasked "wreckers." As for progressive writers, anyone who has learned the history of art or literature from Soviet textbooks will recall that these authors became utterly indistinguishable in accounts that were not real, historical history, but a kind of hagiography that was intended to foster a deindividualized hieratic image. This hagiographic description made no distinction between Goethe and Sholokhov and Omar Khayyám—they all loved the people, were persecuted by scheming reactionary forces, labored for the radiant future, created truly realistic art, and so on.

As is evident from this brief description, the Stalinist reception of the classics differs radically from what was envisaged by the avant-garde in general and Lef in particular in their struggle with the classical heritage. Lef perceived an obvious gap between its own "demiurgic" aesthetics and the contemplative art of the past, which it usually divided into historical styles rather than into reactionary and progressive categories cutting across these styles. Here again we can see the historical limitations of the classical avant-garde, which was a prisoner

of its own all too clearly perceived place in the history of the arts.

In contrast, socialist realism, which regards historical time as ended and therefore occupies no particular place in it, looks upon history as the arena of struggle between active, demiurgic, creative, progressive art aspiring to build a new world in the interests of the oppressed classes and passive, contemplative art that does not believe in or desire change but accepts things as they are or dreams of the past. Socialist realism canonizes the former and dispatches the latter to a second, mystical death in the hell of historical oblivion. According to Stalinist aesthetics, everything is new in the new posthistorical reality—even the classics are new, and these it has indeed reworked beyond recognition. There is thus no reason to strive for formal innovation, since novelty is automatically guaranteed by the total novelty of superhistorical content and significance. Nor does this aesthetics fear charges of eclecticism, for it does not regard the right to borrow from all ages as eclectic; after all, it selects only progressive art, which possesses inherent unity. The reproach of eclecticism would be justified if the quotations were of something the aesthetics had itself determined to be reactionary, and from time to time such charges did in fact threaten writers and artists with dire consequences. Socialist realism as a whole, however, could be considered eclectic only by an outside, formalistic observer who sees nothing but combinations of styles and ignores the high ideological qualities (*ideinost'*) and "popular spirit" (*narodnost'*) that unite them.

Underpinning socialist realism was the Marxist doctrine of dialectical and historical materialism, which defined the socialist revolution as the final stage of a dialectical evolution whose intermediate phases serve as prototypes or symbols anticipating this final and absolute event. This is also the source of the Stalinist dialectical radicalization of the avant-garde, which was defeated as being "metaphysical" and "idealist." Because the avant-garde took an undialectical view of its own project as absolutely opposing or directly negating the past, it

was unable to stand up against the total dialectical irony of Stalin's negation of the negation, which in the practical language of dialectical materialism signified a dual destruction—the unending destruction of the destroyer, the purge of the purgers, the mystical sublimation of human material to distill from it the new "Soviet individual" in the name of Stalin's superhuman, transcendent, transhistorical "new humanism."

THE TYPOLOGY OF THE NONEXISTENT

To distinguish their views from the aesthetics of the avant-garde, the theorists of socialist realism usually insist on the role of art as a means of knowing reality, that is, on its mimetic function, which is what allows the method to be contrasted as "realism" with avant-garde formalism. However, Stalinist aesthetics distances itself no less emphatically from naturalism, associating it with the repudiated "ideology of bourgeois objectivism," which upon closer consideration proves to be what most observers, including the Lef theorists, meant by the term "realism"—the reflection of immediately perceived reality. Mimesis, which in the aesthetics of the Stalin period and even in the Soviet Union today is associated with the so-called Leninist theory of reflection, thus signifies something quite different from an orientation toward the traditional representational easel painting.

An analysis of this distinction must begin with a consideration of the notion of "the typical," a key concept in all socialist realist discourse. One definition that accurately reflects the mature phase in the evolution of the doctrine is in Georgii Malenkov's report at the agenda-setting Nineteenth Party Congress:

As our artists, writers, and performers create their artistic images, they must constantly bear in mind that the typical is not that which is encountered the most often, but that which most persuasively expresses the essence of a given social force. From the Marxist-Leninist standpoint, the typical does not signify

some sort of statistical mean. . . . The typical is the vital sphere in which is manifested the party spirit of realistic art. The question of the typical is always a political question.

After thus quoting Malenkov the journal continues:

Thus, in the way the typical in the life of society is brought out in the artistic representation, we can see the political attitude of the artist toward reality, social life, historical events.[17]

Socialist realist mimesis, then, attempts to focus on the hidden essence of things rather than on phenomena. This is more reminiscent of medieval realism and its polemics with nominalism than of nineteenth-century realism. Medieval realism, however, did not observe any principle of party spirit and did not claim to provide political guidelines—not even to resist the temptations of the devil—because it focused on that which exists, on the true essence of things. Socialist realism is oriented toward that which has not yet come into being but which should be created, and in this respect it is the heir of the avant-garde, for which aesthetics and politics also are identical. The notion of the typical was based on the following statement by Stalin:

What is most important to the dialectical method is not that which is stable at present but is already beginning to die, but rather that which is emerging and developing, even if at present it does not appear stable, since for the dialectical method only that which is emerging and developing cannot be overcome.[18]

If it is further considered that what is regarded as dialectically emerging and developing under socialism is that which corresponds to the latest party policies, and that anything that runs counter to these policies is becoming obsolete, then it is obvious that the former will eventually prevail and the latter will be destroyed. The connection between the typical and the principle of partymindedness, or *partiinost'*, is thus clear: the portrayal of the typical refers to the visual realization of still-emerging party objectives, the ability to intuit new currents among the party leadership, to sense which way the wind is

blowing. More precisely, it is the ability to anticipate the will of Stalin, who is the real creator of reality.

This explains why so many writers, artists, movie-makers, and so on were afforded access to privileged party circles and encouraged to participate directly in the Stalinist power apparatus. It was not a case of a vulgar "bribe"—like everyone else, cultural figures could be made to work by intimidation. The point instead is that they were thus given an opportunity to glimpse "the typical" that they were expected to reflect in their works. That is, they were provided an insight into the process through which reality was molded by the party leadership, and since they belonged to this leadership, it was a process in which they could even personally participate. As party bureaucrat the Soviet artist is more an artist, more a creator of the new reality, than in the studio in front of the easel. Thus what is subject to artistic mimesis is not external, visible reality, but the inner reality of the inner life of the artist, who possesses the ability to identify and fuse with the will of the party and Stalin and out of this inner fusion generates an image, or rather a model, of the reality that this will is striving to shape. This, then, is why the question of the typical is a political question—an inability to identify with the party is reflected externally in the inability to select the "correct" typical and can only indicate political disagreement with the party and Stalin at some subconscious level. The artists themselves may not even be aware of such dissension, but subjectively consider themselves completely loyal. Although it might seem irrational from the viewpoint of another aesthetics, here it is quite logical to eliminate artists physically for the differences between their personal dreams and that of Stalin.

Socialist realism represents the party-minded, collective surrealism that flourished under Lenin's famous slogan "it is necessary to dream," and therein is its similarity to Western artistic currents of the 1930s and 1940s. The popular definition of the method as "the depiction of life in its revolutionary development," "national in form, socialist in content," is based on this dream realism, in which a national form con-

ceals the new socialist content: the magnificent vision of a world built by the party, the total work of art born of the will of its true creator and artist—Stalin. Under these circumstances, to be a realist means to avoid being shot for the political crime of allowing one's personal dream to differ from Stalin's. The mimesis of socialist realism is the mimesis of Stalin's will, the artist's emulation of Stalin, the surrender of their artistic egos in exchange for the collective efficacy of the project in which they participate. "The typical" of socialist realism is Stalin's dream made visible, a reflection of his imagination—an imagination that was perhaps not as rich as that of Salvador Dali (possibly the only Western artist recognized, albeit negatively, by contemporary Soviet critics), but was far more efficacious.

Light is also shed on the nature of the typical by specific recommendations of artists on how to achieve it. Particularly interesting in this regard is a speech by the prominent painter Boris Ioganson in which he attempts a concrete, practical interpretation of the theoretical tenets of socialist realist aesthetics. Repeating first the familiar theses that all art is partisan in nature and that "the so-called theory of art for art's sake" was devised "to seize an ideological weapon from the progressive forces of society," Ioganson proceeds to Lenin's theory of reflection, according to which

> the eye reflects objects as they appear to us, but human cognition of the surrounding world . . . depends on thought. [Thus] . . . the peculiarity of the artistic image as a subjective reflection of the objective world consists in the fact that the image combines the immediacy and power of active contemplation with the universality of abstract thought.
>
> . . . Herein lies the great cognitive significance of realism, the distinction between realism and naturalism in art. Absolutization of the isolated detail leads to naturalism, to a decrease in the cognitive value of art.[19]

This thesis Ioganson illustrates with the following passage from Gor'kii:

A fact is still not the whole truth; it is merely the raw material
from which the real truth of art must be smelted and ex-
tracted—the chicken must not be roasted with its feathers. This,
however, is precisely what reverence for the fact results in—the
accidental and inessential is mixed with the essential and typi-
cal. We must learn to pluck the fact of its inessential plumage;
we must be able to extract meaning from the fact.[20]

Unlike most other contemporary critics, however, Ioganson
does not limit himself to this quotation of "the father of social-
ist realism" describing the typical as a "plucked chicken" and
the method itself as the plucking, but goes on to make some
specific recommendations. There are, he says, examples of
pure naturalism:

A casually snapped color photograph in which composition and
the purposeful will of the photographer are absent is pure natu-
ralism. A color photograph taken with a definite purpose in
mind and edited by the photographer's will, however, is a mani-
festation of conscious realism . . . If the formal element of
execution is connected with the artist's intent, it is a realistic
element. . . . Thus the naturalistic and realistic approaches to
photography can be distinguished according to the presence or
absence of the will or purpose of the photographer. The will of
the craftsman, artistic production, especially in the cinema
(casting, makeup, etc.) is analogous to the will of the painter.
Everything must contribute to expressing the basic idea of the
work of art.[21]

Thus, after decades of bloody struggle with formalism, it
suddenly turns out that "the formal element of execution . . .
is a realistic element." In this passage Ioganson is undoubtedly
continuing to polemize with avant-garde critics who main-
tained that socialist realist art in general and Ioganson's paint-
ings in particular were merely color snapshots that in the age
of photography had therefore become superfluous, redundant
anachronisms. Art should instead work immediately with
"the unplucked fact," that is, the photograph. Ioganson is al-
luding to the already noted naiveté of the avant-garde, which

regarded photography, the cinema, and so on as such "facts" that had from the outset been "plucked"—directed, juggled— by the will of the artist-photographer. He agrees with his "formalist" critics that his works are little more than enlarged color photographs, but he denies that they are any the less "creative" for that. Instead, it is the transition itself from photography to painting, the change of technique, that reveals the photographer's artistic will behind the factuality of the photograph. Thus socialist realism candidly formulates the principle and strategy of its mimesis: although it advocates a strictly "objective," "adequate" rendering of external reality, at the same time it stages or produces this reality. More precisely, it takes reality that has already been produced by Stalin and the party, thereby shifting the creative act onto reality itself, just as the avant-garde had demanded. This transfer is more "realistic," however, in the sense that it reflects a political pragmatism that contrasts with the naive utopianism of the avant-garde.

The "theater" and "stagecraft" metaphor is anything but accidental in this context. As one influential critic of the time noted:

> The typical hero should possess a striking, vivid personality. Sometimes it seems that not only the spectator but even the artist has no really clear idea of the heroes of a work—their desires, their aspirations, their character traits, why they are where they are or where they are going. I think that here our artists could learn a great deal from Stanislavskii, who demanded that his actors express each separate personality even in crowd scenes; even if they uttered only two or three sentences they were required to embody a specific personality.[22]

Thus the socialist realist painting is not primarily intended to produce a visual effect or to render "the beauty of Nature" in the manner of traditional realism. Instead, it conveys the inaudible speech of the individuals it portrays, glimpses into their lives, looks for signs of good and evil, and so on. The mimetic nature of the socialist realist picture is a mere illusion, or rather yet another ideologically motivated message among

the other messages making up the painting. More than a true "reflection" of any reality, the work is a hieroglyphic text, an icon, or a prescriptive newspaper article. The three-dimensional visual illusion of the socialist realist painting can be broken down into discrete signs bearing a "supersensual," "abstract" content; it is read by spectators familiar with the appropriate codes and is evaluated on the basis of such a reading rather than on the virtue of its own visual properties. This is why the socialist realist painting judged by the traditional criteria of realistic art inevitably appears "inferior" and "bad." To the trained eye, however, it is no less rich in content than the Japanese No theater. To the viewer of the Stalin period, moreover, it offered the additional and truly aesthetic experience of terror, since an incorrect coding or decoding could mean death. Despite its surface radiance and prettiness, the socialist realist painting evokes in the Soviet citizen of especially that period the same awe that the Sphinx inspired in Oedipus, who did not know which of his interpretations would mean patricide—that is, Stalinicide—and thus his own death. Happily, to the modern viewer such pictures are as trite as the Sphinx, but the fact that they must be kept locked up in the cellars indicates that even today they have not entirely lost their former charms.

THE EARTHLY INCARNATION OF THE DEMIURGE

The radicalization of avant-garde aesthetics described above, of course, does not exhaustively explain why the notion that art must be an autonomous sphere of activity—a concept the avant-garde had always rejected—triumphed in the 1930s. Eclecticism and the total organization of life, it would seem, did not necessarily require socialist realist figurative duplication. The whole point, however, is that we do not have to do with any such simple duplication. It became clear as early as the 1920s that the total avant-garde project left one important lacuna that the avant-garde could not fill on its own, namely the image of the author of the project. By usurping the place of God, the avant-garde artist transcends the world he has cre-

ated; he does not belong to this world, he has no place in it, for humanity is gone from avant-garde art. This creates the not entirely unfounded impression that although he creates a new world, the avant-garde artist remains in the old one—in the history of the arts, in tradition—rather like Moses on the threshold of the Promised Land. All aspirations toward the new notwithstanding, from the viewpoint of socialist realist aesthetics the avant-gardist is "decrepit" and a "formalist." That is, his projection of the new is merely logical, formal, and "soulless," for his soul is still in the past. At the center of socialist realist art, therefore, we find the image of the "New Man" as described by Comrade Zhdanov: "We must . . . shake off the decrepit Adam and begin working like Marx, Engels, and Lenin, like Comrade Stalin."[23]

Ia. A. Tugendkhol'd penetratingly described the crisis of the Russian avant-garde as early as the 1920s. Noting the "hypertrophy of analytical rationalism" in the leftist painting of the decade, Tugendkhol'd goes on to question the main premise of this art, which is that since the artist controls the form and color that act directly on the human subconscious, by changing the human environment he will also automatically shape the human psyche and consciousness.

> Malevich demanded that "the spiritual power of content be rejected because it is an attribute of the green world of meat and bone." . . . Punin argues that "no spiritual life, no content, no 'plot' [siuzhetchina] is necessary." All that is needed is form. Why? Because "it is being that determines consciousness, not consciousness that determines being. Form – being. Form/being determines consciousness, i.e., content," Punin writes. "We," he exclaims, "are monists; we are materialists, and that is why our art is our form. Our art is an art of form, because we are proletarian artists, artists of Communist culture."[24]

Tugendkhol'd responds as follows to these "formalist" arguments:

> Punin failed to understand that since this form of the age is mandatory for all, the distinction between proletarian and non-

proletarian art happens to be found not in form, but in the *idea*
of the use of this form. Locomotives and machines are the same
here as in the West; this is our "form." The difference between
our industrialism and that of the West, however, is in the fact
that here it is the proletariat that is the master of these locomo-
tives and machines; this is our content.[25]

When he brings up the technological backwardness of Russia
and the sameness of Soviet and Western technology, of course,
Tugendkhol'd is arguing like a typical fellow-traveler. Such
views would later be condemned as slanderous "cosmopolitan
groveling before the West" and Tugendkhol'd would be re-
jected by Stalinist culture, but here he is in essence expressing
its central argument.

If at first the avant-garde and orthodox Marxists truly be-
lieved that consciousness was determined by the material
base, this belief rather quickly dissipated for two, seemingly
opposite, reasons. First of all, the human consciousness
proved far less flexible than had been supposed previously,
when it was sincerely thought that a simple change in condi-
tions would automatically produce a change in consciousness.
Thus the theorists unexpectedly found the consciousness of
the "new individual" to be the main stumbling block. Since
the Russian base continued to lag behind that of the West,
however, this new consciousness was the sole basis and guar-
antee for the building of socialism. This in turn meant that to
speak of socialism one must, like Tugendkhol'd, resort to
purely psychological terms such as "the socialist attitude of
the Soviet individual to labor." In both the positive and nega-
tive respects, then, the fate of socialism is defined and decided
psychologically, whence Stalin's famous change of slogans
from "technology decides everything" to "the cadres decide
everything."

Like the 1930s in Europe, Stalinist culture rediscovered
human subjectivity and a new romanticism. The way to this
upheaval, of course, had already been paved by Leninism, par-
ticularly when Marxist theory was proclaimed "the victorious
ideology of the proletariat" that was to conquer "decadent

bourgeois ideology." Thus instead of a critique of ideology Marxism was itself declared an ideology; more precisely, although it remained a critique of ideology it began to be interpreted as an ideology. Hence such formulas typical of the Stalin period—and of our day as well—proclaiming that "history is driven by the victorious teachings of Marx, Engels, Lenin, and Stalin." The materialist determinism of history, in other words, began itself to determine history. As Lenin had said: "Marx's teaching is omnipotent because it is true." In this slogan, which embellishes most Soviet cities, the essence of Lenin's revolution is perfectly clear. From the orthodox Marxist point of view, in contrast, Marxism is true because it is invincible, meaning that it corresponds to the objective logic of materialistically determined history. In this respect Leninism and Stalinism can be considered thoroughly idealistic, and to this day one can read in Soviet textbooks of philosophy that history is determined by great ideas, the greatest of which is the Marxist notion that history is determined materialistically. Only someone with an inadequate grasp of Soviet dialectical thought, of course, could be puzzled by such a statement.

Be that as it may, we cannot comprehend the Stalin period unless we consider Stalin's famous declaration, "Life has become better, comrades; life has become more joyous." The source of this joy was not any improvement in material conditions but the realization that such things were beside the point. Liberation from the "formalism," "machinism," and "leveling" of the preceding avant-garde period was itself experienced as happiness. At the same time, the struggle against formalism also connoted a struggle against bureaucratic formalism. Among the characteristic traits of Stalinist literary heroes is their ability to perform obviously superhuman feats, and they derive this capability from their refusal to approach life "formalistically." Thus they can cure tuberculosis by willpower alone, raise tropical plants in the open air of the tundra, paralyze their enemies with the power of their gaze, and so on.[26] Without any additional technology, by proletarian willpower alone, the Stakhanovite movement increased labor pro-

ductivity manyfold. Ignoring "formalist genetic methods," Academician Lysenko transformed certain plant species into completely different ones.

The slogan of the age became "Nothing is impossible for a Bolshevik." Any reference to facts, technical realities, or objective limits was treated as "cowardice" and "unbelief" unworthy of a true Stalinist. It was thought that willpower alone could overcome anything that the bureaucratic, formalistic eye perceived as an insurmountable obstacle. The model of such an iron will was Stalin himself, for whom, since it appeared to be his will alone that drove the entire country, nothing was impossible. Generations were raised on the examples of Pavka Korchagin and Mares'ev,[27] invalids who overcame their physical infirmity through sheer willpower. These characters are in a sense undoubtedly symbolic of Stalin's will, whose mighty power was felt throughout the land despite the Leader's sedentary reclusion within the Kremlin walls.

Incidentally, widespread formulas of the time such as a "will of steel" or the endlessly repeated song lyrics "we have wings of steel and a fiery engine for a heart" are extraordinarily well suited to the image of the "engineer of human souls," for they seem to suggest that the individual has absorbed technology and that the former irrational faith in technological might has been transformed into an equally irrational faith in latent human powers. The technical organization of the world became merely the visible realization of the inherent powers of its creator, and the solitary, suffering, self-sacrificing artist-hero of the avant-garde became the hero of Stalinist culture—now, however, as a sportsman, polar aviator, factory manager, collective farm party organizer, and so on—that is, a real creator of real life rather than simply a builder of castles in the air.

The depths of the human psyche, of course, revealed to Stalinist culture not only "creative might," but also a potential for negation and destruction. Loyal and well-known Communists suddenly turned out to be monsters capable of demoniacal, spontaneous, and unprovoked malice and violence. They incarnated the other, destructive side of the avant-garde,

whose passion for negating the past to clear the way for the new was as absolute as the creative energy it devoted to its artistic project. As Tret'iakov observed elsewhere in the article cited above: "Futurism was never a school. It was a socio-aesthetic tendency, the strivings of a group of people whose common point of tangency was not even positive tasks, . . . but rather a hatred for their 'yesterday and today,' a relentless and merciless hatred."[28] The figure of the "wrecker" that is so important to Stalinist mythology is no more "realistically" motivated than the superhuman power of creation in the "positive hero." The show trials of the 1930s demonstrated that seemingly quite normal persons were capable of strewing ground glass in the food of the workers, giving them smallpox and skin disease, poisoning wells and public places, infecting livestock with anthrax, and so on. Moreover, they did all this on a superhuman, unimaginable scale, accomplishing the most titanically destructive feats in many places at the same time but without any technical or organizational assistance (since that would eliminate their individual guilt), and by will-power alone (since they were the whole time working for the party and under its supervision).

That the actions of the show-trial defendant defied ordinary human logic was usually even emphasized in the accusation, because this inexplicability was evidence that his evil will was absolute and incorrigible and could only be subdued by physi-cally eliminating the individual. Thus in view of the entire country the soul of an ordinary, seemingly unremarkable per-son opened to reveal enormous superhuman energy, and this, of course, could not but influence how the culture viewed hu-manity as such. Especially literature began to depict demo-niacal doubles who destroyed everything the demiurge created (for example, in Veniamin Kaverin's *Two Captains* or Leonid Leonov's *Russian Forest*). Thus neither the positive nor the negative characters of Stalinist culture belong to the reality in which they act; they are not linked to it through the ordinary psychological motivations typical of genuine realistic litera-ture or art. Here again the true nature of Stalinist art will be obscured if study is limited to a superficial consideration of the

traditional realistic forms of narrative, theater, cinema, paint-
ing, and the like that it employs. The positive and negative
heroes of Stalinist culture are the two faces of the preceding
avant-garde demiurge, and they transcend the reality they cre-
ate or destroy. Likewise, the struggle between them takes
place not within but beyond the sphere of the real, and reality
itself is merely a stake in the game.

There is no place in avant-garde aesthetics for demonstrat-
ing this struggle, because it is waged outside the total aesthetic
project that embraces the entire world. David Burliuk's lines,
"Everyone is young, young, young, and there's a *devilish* hun-
ger in their bellies,"[29] (italics added) and his subsequent call to
devour the whole world eloquently illustrate the fact that both
the creative and the destructive sides of the avant-garde oper-
ate in a space that transcends both the present and future
worlds, so that they are completely irrational if judged by or-
dinary earthly criteria. The energy of the avant-garde destruc-
tion of the old world and the demoniacal force of its provoca-
tion derive not from worldly passions, but from an absolute,
transcendental event—the death, or rather the murder, of
God—the same source from which it draws its superhuman
creative energy. The moment the avant-garde artist's position
is occupied by the party leadership and the real figure of "the
new individual, the rebuilder of the Earth," the avant-garde
myth becomes a subject for art, and the figure of the avant-
garde demiurge breaks down into the Divine Creator and his
demoniacal double—Stalin and Trotskii, "the positive hero"
and "the wrecker."

The above remarks explain both the resurrection of autono-
mous art in the Stalin period and its quasi-mimetic features.
The goal of this art is to "reflect" or render visible the struggle
to determine the destiny of the world and the protagonists of
the struggle. The "materialistic art" of the avant-garde could
not do this, for it failed to understand that what decides every-
thing is not the "means of production" themselves, but their
mode of employment, that is, the "relationship to them." The
art of socialist realism, therefore, is not realistic in the tradi-
tional sense of the word; that is, what it provides is not a re-

flection of worldly events in their worldly contexts and motivations, but hagiographic, demonological, and other such depictions of transcendental events and their worldly consequences. It is not for nothing that socialist realist aesthetics always speaks not of "portraying" positive or negative heroes, but of "incarnating" them by artistic means. In and of themselves the positive and negative heroes have no external appearance, because they express transcendental demiurgic forces. However, to demonstrate these forces in a manner that is "intelligible to the people" (the "people" here meaning not actual consumers of art but mortals who lack transcendental vision), they must be symbolized, incarnated, set upon a stage. Hence the constant concern of socialist realist aesthetics with verisimilitude. Its heroes, as is stated in certain of the quotations cited above, must thoroughly resemble people if people are not to be frightened by their true aspect, and this is why the writers and artists of socialist realism constantly bustle about inventing biographies, habits, clothing, physiognomies, and so on. They almost seem to be in the employ of some sort of extraterrestrial bureau planning a trip to Earth—they want to make their envoys as anthropomorphic as possible, but they cannot keep the otherworldly void from gaping through all the cracks in the mask.

This "self-staging" of the avant-garde demiurge is also characteristic of other artistic currents of the 1930s and 1940s, particularly surrealism, with which, as with the art of Nazi Germany, socialist realism has a great deal in common. All that distinguishes surrealism or magic realism from the totalitarian art of the time is the "individual" nature of its staging, which was confined to "art," whereas in Germany or Russia the predicates of the surrealistic artist-demiurge were transferred to the political Leader. The kinship of these tendencies is also apparent in the conversion of a number of French surrealists to socialist realism and fascism, Salvador Dali's interest in the figures of Lenin, Stalin, Hitler, and others.

A great deal has been written recently on the proximity of socialist realism to the ritualistic, sacred art of the past, on the

theatrical and magical nature of its artistic practice, its use of forms of "primitive thought" resembling those described by Levy-Bruhl, and its continuity with medieval Russian and Western Christian prototypes. These publications, among which special mention should be made of V. Papernyi's *Kul'tura 2* and Katerina Clark's *The Soviet Novel: History as Ritual*,[30] contain many valuable observations and penetrating analyses of the impact on Stalinist culture of sacred archetypes familiar from the art of other religiously oriented periods. All of these studies, however, neglect to inquire why this quasi-sacred art arose where and when it did; more precisely, they treat it in the usual sociological spirit as a "lapse" of Russian culture into a "primitive state" or "pure folklore." Papernyi, for example, considers such lapses as typical of Russian history in general. This leads him, in effect, to deny the specific characteristics of Stalinist culture, which he, Clark, and many others consider quite apart from the striking analogies that can be observed in the contemporary culture of other countries. It is instead assumed that Stalinist culture somehow falls outside the entire historical process. As I have already noted, this assumption suggests that, though these scholars may be critical of Stalinist culture on the conscious level, subconsciously they have been transfixed by its claim to have transcended history.

The reason that the historical position of Stalinist culture cannot be determined even though its mechanisms have been fairly thoroughly described is that the rationality, technicality, and materialism of the avant-garde that preceded it have been greatly overestimated. Although the design of the avant-garde artistic project was rationalistic, utilitarian, constructive, and in that sense "enlightenist," the source of both the project and the will to destroy the world as we know it to pave the way for the new was in the mystical, transcendental, "sacred" sphere, and in that sense completely "irrational." The avant-garde artist believed that his knowledge of and especially participation in the murder of God gave him a demiurgic, magical power over the world, and he was convinced that by thus crossing the boundaries of the world he could discover the

laws that govern cosmic and social forces. He would then re-generate himself and the world by mastering these laws like an engineer, halting its decline through artistic techniques that would impart to it a form that was eternal and ideal or at least appropriate to any given moment in history. All of this certainly belongs to a mystical order of experience that differs from the simple utilitarianism of form and transparency of construction to which the avant-garde is usually reduced by those who consider it only in the context of the museum or of design. Khlebnikov, Kruchenykh, and Malevich's mystery, *Victory over the Sun*, in which the sign of the black square first appeared, reproduces this "murder of the sun" and the falling of a mystical night in which is ignited the artificial sun of the new culture and new technological world. The avant-garde itself was perfectly aware of the sacred dimension of its art,[31] and socialist realism preserved this knowledge. The sacred ritualism of socialist realist hagiography and demonology describes and invokes the demiurgic practice of the avant-garde. What we are dealing with here is not stylization or a lapse into the primitive past, but an assimilation of the hidden mystical experience of the preceding period and the appropriation of this experience by the state. An analogy with the "death of the Christian God" in the history of the church is appropriate, because it is an integral part of the ecclesiastical history of Christianity and not merely an artificial stylization of previous models. Though it was ever ready to quote the past, Stalinist culture was not a stylization. On the contrary, in using the experience of the past it always strove to distance itself from the past by reading it unhistorically and "incorrectly" and incorporating it into the context of its own posthistorical existence.

Critics of the late 1920s and early 1930s repeatedly cited the necessity of returning to traditional forms of art to "incarnate the image of the new man," that is, the superman or demiurge. Particularly characteristic here are some remarks by Tugendkhol'd, who links the turn to realistic painting in the mid-1920s with the shock of Lenin's death. He writes: "When Lenin died, everyone sensed that something had been

lost, that now it was necessary to forget all 'isms' and keep his image for posterity. All currents were agreed that it was desirable to preserve Lenin."[32] Thus as the focus shifted from the project to its author, Lenin became more important than "Leninism."

The Lenin cult was very significant both in the political legitimization of Stalin and in the evolution of socialist realism, since even before Stalin came to power Lenin had been proclaimed the model of the "new man," "the most human of all human beings." Maiakovskii's slogan "Lenin is more alive than the living" adorning the streets of Soviet cities does not contradict the cult of Lenin's mummy in the mausoleum (perhaps one of the most mysterious in the history of world religion). Although I shall not attempt an exhaustive description of the cult here, it does deserve a few words. It has undeniably exerted a hidden formative influence on all subsequent Stalinist and post-Stalinist Soviet culture, if for no other reason than the central position it occupies in the invisible Soviet sacred hierarchy. Twice a year, "the entire Soviet land" submits its "report" in parades and demonstrations that pass by the mausoleum, and the leaders who accept this report stand on the roof of the structure, symbolically basing their power on the mummy of Lenin concealed within.

The construction of the mausoleum on Red Square and the founding of the Lenin cult were vigorously opposed by traditional Marxists and the representatives of left art. The former spoke of "Asiatic barbarism" and "savage customs unworthy of Marxists." Lef also reacted to the first temporary variant of the mausoleum, which was later slightly simplified, describing it as "a verbatim translation from the ancient Persian" that resembled the grave of King Cyrus near Mugraba. Such criticism today, of course, is no longer possible—not only because the mausoleum was long ago pronounced "sacred to all Soviet citizens," but also because everyone got used to it long ago.

The Lef critics, who perceived in Lenin's mausoleum only an analogy with ancient Asian tombs, were as usual blind to the originality of the new Stalinist culture taking shape before their very eyes. The mummies of the pharaohs and other an-

cient rulers were walled up in pyramids and concealed from mortals—opening such graves was considered sacrilege. Lenin, in contrast, is on public display as a work of art, and his mausoleum, as is evident from the long lines that have formed before it every day for decades, is without a doubt the most frequented museum in the Soviet Union. If the "militant atheists" of the time exhumed the relics of saints and exhibited them in museumlike displays as antireligious propaganda, Lenin was from the outset simultaneously buried and displayed. The Lenin mausoleum is a synthesis between a pyramid and a museum that exhibits Lenin's body, the mortal husk he shed to become the personification of the building of socialism, "inspiring the Soviet people to heroic deeds."

Another significant fact is that whereas mummies are traditionally dressed in garments marking the transition of the mortal into the other world, Lenin's external appearance has been "realistically" reconstructed down to the last detail as he was "in life." This is often done at funerals today *before* the body is consigned to the grave, which is further evidence of the universal character of the religiosity embodied in the mausoleum. It might be said that if earlier the body of the deceased was honored because of its absolute otherness, because it belonged to a world that was an alternative to the earthly one and—as in Judaism and Christianity—because it offered the hope of resurrection, Lenin's body is revered precisely because the deceased has irrevocably parted from it. In other words, it no longer corresponds to any spiritual reality. In this sense, Lenin's body is venerated and displayed as evidence of the fact that he has forever departed from the world, as a testimony that he has abandoned this embodiment of his without a trace and that therefore his spirit or "cause" is available for incarnation in subsequent Soviet leaders. Lenin's corpse on display, which has not been and cannot be transfigured but remains "as it might have appeared on the day of his death," is meant to offer eternal proof that he really and irrevocably died and will not be resurrected, and that the only appeal that can be made to him is through the heirs who now stand upon his tomb. In this sense the removal of Stalin's body from the mau-

soleum and its burial indicate that the culture is unable to rec-
ognize the finality of his death and to free his spirit for further
incarnations (it is no coincidence that Evtushenko's poem
"The Heirs of Stalin," written on the occasion of the removal,
expresses apprehension that Stalin's work will be continued).

"Immortality in deeds" and the passing on of the spirit to
the individual's heirs after death are constant themes in Soviet
culture and are aptly expressed, for example, in the wide-
spread slogan, "Stalin is the Lenin of our day." Thus because
it signifies the complete end of Lenin's autonomous existence
outside and apart from his "work," the body in the mauso-
leum served to confirm the totality of Stalin's power, which no
one's presence could limit even in the transcendental world
and which no resurrection or Judgment Day could call into
question. Lenin's mummy can at the same time be regarded as
the model for the "incarnations" of the socialist realist hero;
the external "human" wrapper is here merely that: a shell, a
husk donned by the demiurgic and dialectical forces of history
that they may manifest themselves and then exchange it for
another. Thus ex post factum it is Lenin, and not the avant-
garde claiming the role, who is acknowledged to be the
demiurge of his age. It must also be recognized that "left art"
itself had a hand in this canonization of Lenin: recall
Maiakovskii's poem sanctifying him, or the collection of arti-
cles by the Opoiaz formalists Shklovskii, Tynianov, Eikhen-
baum, and others who analyzed Lenin's style. Considering the
rigor of Opoiaz's criteria, such analysis is tantamount to rec-
ognizing him as an artist, a creator.[33]

If Lenin was canonized after the fact, Stalin's image in art—
as the genuine new man, the model for every builder of social-
ism, the true creator of the new life—allowed him to see his
own reflection in the work of art he had created, because as a
new Soviet individual, the artist could not be understood ex-
cept as "inspired by the spirit of Stalin," as created by Stalin.
In this sense the portraits of Stalin—the greatest achievement
of socialist realist art—are reflections of the demiurge itself
and thus the concluding stage of the dialectical process. It is in
this sense that we must understand Stalin's famous directive to

writers and cultural workers in general to "write the truth."
As was mentioned earlier, this refers not to an external, static
truth, but to the inner truth in the artist's heart, his love for
and faith in Stalin. As opposed to the avant-garde's "formal-
ism," its insincere, devious "devices" and emotional empti-
ness and callousness, Stalinist culture is therefore moved
above all by a spirit of sincerity and immediacy. The artist of
Stalinist culture is a medium who spontaneously praises and
condemns according to the inner dictates of the heart. The
state judged the condition of the artist's heart on the basis of
this spontaneous evidence, and even if the diagnosis was nega-
tive and the disease incurable, blame was placed not on the
bards themselves, but on the appropriate party organization
for failing to educate them properly and for "permitting dis-
ruption and waste in its ideological work." The writers them-
selves even inspired a kind of respect, serving as examples of
"honest enemies" to the "insincere," cowardly formalists,
who were called upon to finally reveal their "true faces" so
that they could be befittingly liquidated.

This profound romanticism of Stalinist culture, for which
the heart of the artist was either possessed by a divine thirst
for good and gratitude to his creator Stalin or had been se-
duced by "the wrecker," naturally generated a cult of love as
a kind of "inner utopia" that succeeded the external mechani-
cal utopia of the avant-garde. The favorite heroes of Stalinist
culture became Romeo and Juliet, Carmen, and the like, quite
in accordance with Stalin's famous pronouncement on one of
Gor'kii's stories: "This piece is more potent than Goethe's
Faust. Love conquers death." If the avant-garde artist as-
sumed that it was enough simply to build the world as a ma-
chine for it to begin moving and living, Stalin understood that
in order to awaken life in the machine you must first arouse
love for its creator. Death would not be conquered until the
new human beings created by Stalin joined with their maker in
a mystical union, surrendering their own wills so that the will
of the creator be done.

The obvious "Byzantine" attributes of Stalinist culture and
its saturation with Christian symbolism are often traced to

Stalin's theological training and traditional Russian piety, which was now frustrated and transferred to a new object. All such superficial sociological explanations, however, are unsatisfactory. The usurpation of God's role and the reconstruction and reinterpretation of the myth of God the Artist who shapes "life" and "overcomes the resistance of the material" are all hidden avant-garde mythologemes. These mythologemes, which render the avant-garde a primarily religious or mystical phenomenon rather than the technological and rational entity it seems to be at first glance, did not surface until the Stalin period. Moreover, if the figure of the avant-garde demiurge split into the infinitely good "grandfather" Lenin and the infinitely evil "wrecker" Trotskii, Stalin himself—despite his indubitable sanctity—also displays a great many demonic attributes. For example, he works at night, when "normal people" are asleep, his prolonged silence is frightening, and his unexpected interference in debates or everyday affairs often seem to be ambivalent provocations.[34] Thus he ensures to the full that he is both sincerely revered and held in awe.

This new cult of the protean "dialectical demiurge" that succeeded the traditional Christian cult of a God who was uniquely incarnated and retained his self-identity perhaps consummates the avant-garde's most important creative impulse, which was to bring forth the superindividual, extrapersonal, and collective in art, to transcend the limits of the earthly, mortal "creative individuality." Although all avant-garde artists declared their projects to be extrapersonal, cleansed of everything accidental, purged of the artist's "nature," or individual, spontaneous reactions, these projects remained individualized to the highest degree, because the very demand that a project be constructed in opposition to "automatized life" and the typically avant-garde set on novelty and originality obviously contradicted its ambitions for universality. Here again the result of reduction, be it ever so radically executed, depends on *what* is being reduced, on the context of the avant-garde projection. Each act of reduction was declared to be final—a reduction to absolute zero that rendered all further reduction impossible, the sole and definitive incarnation of the ambivalent, destructive, and creative demiurgic principle. Yet

each time it turned out that the reduction could be reduced again, and the avant-garde was thus transformed into a ritual that, blind to its own inner mechanics, denied it was ritualistic.

Despite its thoroughly romantic insistence on the individuality and spontaneity of the artist, socialist realism very quickly succeeded in unifying cultural life by fusing all hearts together with the same love and the same fear of Stalin. The discovery of superindividual strata of the creative and the demonic in the individual destroyed individuality and with it classical realism, or "naturalism," from within and in a certain sense forever. Stalinist art is an almost unbroken monolith. Especially in the later period, multifigured compositions were like major architectural projects done by the "brigade method." Literary works as well were rewritten so many times in response to instructions issuing from a variety of sources that they lost their individual authorship. The significance of the museum, whose holdings were merely increased by the avant-garde's futile struggle against it, was accordingly reduced almost to nothing. Just as the avant-garde had demanded, architecture and monumental art now moved to the center of Stalinist culture, and the easel painting that was resurrected on the grave of the avant-garde consequently practically disappeared. All of this, of course, afforded little consolation to avant-garde artists, writers, and critics, who, whatever they might say publicly, wanted individual recognition. Such have all "artists" always been, and such, evidently, shall they ever remain. Although Malevich was placed in a suprematist coffin, he was then very traditionally consigned to the grave, thus describing in the image of this final suprematist construction the actual trajectory of suprematism—all turn to dust again, as Solomon said. Lenin's dust, in contrast, has not yet been consigned to the grave, and, "traditional" though it is, it thus continues to confirm the impersonality and universality of the "work" of its temporary owner. It is difficult to say which of these forms of immortality is the more enviable.

Thus upon closer examination we see that the usual strict dichotomy between the avant-garde and socialist realism derives from the fact that both have been viewed from a false

perspective. This perspective, which both opposed, was the museum exhibition, which had moreover become the symbol of true faith and ethical approbation. With respect to the main ambition of the avant-garde, which was to overcome the museum and bring art out directly into life, socialist realism both reflected and consummated avant-garde demiurgism.

The avant-garde and socialist realism, by which is meant here the art of the Stalin period, also coincide with respect to their motives for extending art into life. Both aspired to resurrect by technological means the wholeness of God's world that had been disrupted by technology; to halt technological progress and the march of history in general by placing it under complete technological control; to conquer time and enter into eternity. Both the avant-garde and socialist realism think of themselves primarily in compensatory terms, contrasting themselves with "individualistic bourgeois decadence" and its impotence to cope with the decay of the social and cosmic whole.

Malevich thought that the *Black Square* had given him access to a vision of the pure materiality coinciding (in the best Aristotelian traditions) with the nothingness that arose after the disintegration of the Divine Logos—the world of Divine Forms, which (interpreted in the best Thomist traditions) were superimposed by God the Artist upon material chaos. Constructivism, on the other hand, demanded that art impart a new form to this chaos by taking the place of the God that progress had killed. Even in its most radical variant of Lef productivism, however, the Russian avant-garde preserved its faith in the dichotomy between the artistic, organized, and crafted word, image, and the like, and that which was unartistic, immediate, everyday, and "material." Consequently, in its practice it replaced work on reality by work on the reflection of reality in the mass media (the newspaper, the photograph, etc.), which had long been manipulated by the state and, to use a modern term, had become a simulacrum of reality.

Drawing upon the experience in manipulation that the party had been accumulating on the social level from the very outset, Stalinist culture declared the primary and the immediate to be the domain of artistic organization. At the same time,

in autonomous artistic activity it thematized the image of the demiurge—the creator of the new reality—in a way the avant-garde was unable to do by its own means. In this respect the art of socialist realism is akin to other currents—surrealism, magic realism, the art of Nazi Germany—in which the creative and the demonic elements of the avant-garde were manifested on the psychological plane. Transcending the historical framework of the avant-garde and eliminating the opposition between artistic and unartistic, traditional and new, the constructive and the everyday (or kitsch), the art of the Stalin period, like the culture of Nazi Germany, claimed to be building a new and eternal empire beyond human history, an apocalyptic kingdom that would incorporate all the good of the past and reject all the bad. This ambition to implement the avant-garde utopian project by non-avant-garde, traditionalist, "realistic" means constitutes the very essence of this culture and therefore cannot be dismissed as a superficial pose. The life-building spirit of the Stalin years resists interpretation as a mere regression into the past, because it insists that it is an absolute apocalyptic future in which distinguishing between past and future is no longer meaningful.

That the theorists of Stalinist culture were themselves aware of its logic is evident from their criticism of the evolution of avant-garde art in the West. Thus L. Reingardt, writing in the ultraofficious journal *Iskusstvo* (*Art*), describes post–World War II Western avant-gardism as a "new academism," the new international style suited to the internationalism of the large (principally American) corporations. He continues:

> Recognition of the latest currents in modern Western art by the wealthy bourgeoisie is tantamount to a death sentence. When they appeared these currents attempted to play on society's hatred of the obsolete order. . . . Now the game of opposing official art is no longer justified. The educated philistines have rushed to embrace their prodigal son. Formalist currents have become the official art of Wall Street. . . . A myriad of advertising firms and speculators create and destroy reputations, finance new currents, manipulate public taste, or rather the lack thereof.[35]

This is a statement that could be endorsed by more than one contemporary champion of postmodernism in the struggle against avant-garde "corporate art."[36]

The vehemence with which Reingardt condemns the avant-garde derives from the profound conviction that, in different forms adequate to the age, Soviet socialist realism preserved the vital modernist life-building impulse that modernism itself lost long ago, when it entered the academies and prostituted itself to its archenemy, the philistine consumer. In this view, the freedom of Soviet art is higher than the pseudofreedom of the Western market. It is the freedom to ignore the tastes of the people and create for the state a new individual and consequently a new people. Although it is with rare exceptions expressed in ethical and political terms, the highest goal in the building of socialism is thus aesthetic, and socialism itself is regarded as the supreme measure of beauty.[37] Before this culture could be regarded from a truly aesthetic perspective, it had to fail and become a thing of the past.

POSTUTOPIAN ART: FROM MYTH TO MYTHOLOGY

IT IS IMPOSSIBLE to describe Stalinism as an aesthetic phenomenon, as a total work of art, without discussing its reception as such in the unofficial or semiofficial Soviet culture of the 1970s and 1980s. By reflecting it and revealing its internal structure, this reception completed Stalin's project, enabling it for the first time to be grasped in its entirety. The retrospective view taken in the 1970s and 1980s, therefore, is anything but extraneous to the culture of the Stalin years. It represents not simply the next stage in the history of Russian art, but is vital to an understanding of the internal logic and true nature of the Stalinist project and demands analysis if the real historical place of that project is to be determined.

After Stalin's death in 1953 and the beginning of what in the West is known as "de-Stalinization" and in the Soviet Union is called the "struggle with the consequences of the personality cult," it became obvious to all that the consummation of world history and the construction of a timeless, millennial apocalyptic kingdom had in reality been based on a chain of demoralizing atrocities and a propagation of ignorance and prejudice that in the cultural respect had turned Soviet society back by decades. The barricades against bourgeois progress that were supposed to protect the country from the flood of historical change now crumbled as the Soviet Union sought to return to history. Some time passed before it was realized that there was nowhere to return to, for history itself had in the meantime disappeared. The entire world entered the posthistorical phase when—and here Stalin's experiment played a part—it lost its faith that history could be overcome. For when history no longer strives toward consummation, it disappears, ceases to be history, stagnates.

The first results of de-Stalinization surprised observers (especially Western ones) who, believing that Stalinism represented a mere regression with respect to the preceding progressive, rationalist, Westernizing, avant-garde period of Russian history, expected that once the Stalin nightmare was over Russia would simply continue this "violently interrupted evolution." Nothing of the kind occurred, of course, because everyone in the Soviet Union sensed intuitively that Stalinism was merely the apogee of triumphant utopianism. Instead of the expected avant-gardist response, therefore, the reaction to Stalinism was thoroughly traditionalist.

Socialist realism began to yield to a traditional realism whose most typical and influential representative in the thaw years was Aleksandr Solzhenitsyn. Utopian dreams of the "new human being" were replaced by a focus on the "eternal values" embodied in the Russian people, who had "suffered" the Revolution and Stalinism, which now seemed to be a kind of fiendish and alien illusion that had come to Russia from the West and had been spread mostly by foreigner Latvians, Jews, Chinese, or at least by Westernized nineteenth-century Russian emigrés—those "nihilist devils," as Dostoevskii called them in *The Possessed*.

The form in which Solzhenitsyn expressed this position was so extreme that it led to his deportation. Slightly veiled and muted, during the 1960s and 1970s it became the dominant ideology in official Soviet circles. It is preached by the village writers, whose works are printed in the millions and who occupy a prominent position in the official cultural industry—suffice it to mention Valentin Rasputin, Viktor Astaf'ev, and Vasilii Belov—and by many influential Soviet philosophers, literary critics, and others. Here it must be observed that Western observers are often insufficiently aware of this new configuration of ideological tendencies. Mechanically assuming that the neo-Slavophile notions of a Solzhenitsyn run counter to official ideology, they are inclined to regard their spread as a sign of "liberalization." In reality, however, Soviet ideology has evolved considerably in recent years, and, although it continues to appeal to the same "classics of Marx-

ism-Leninism," these are now interpreted in a completely new spirit. (This tendency of Soviet ideology to call new things by old names in order to preserve the historical continuity of power is what most often leads outside observers to misinterpret the degree and nature of actual changes.) But it is precisely the slogans of the historical rupture and the building of an unprecedented, new society and new individual that Soviet ideology has now abandoned, shifting the accent to the likewise far from novel idea that the Soviet order embodies the "eternal human ideal of a better life" and the "age-old moral values" that have been corrupted in the West by progress and the spirit of pluralism and permissiveness. In other words, it is precisely now that Soviet ideology is truly becoming traditionalist and conservative, and in this process it willingly appeals, above all, to traditional Russian values, including a purely moralistically interpreted Christianity. Remaining unchanged in this ideology is its collectivist essence, which precludes treating the individual as anything but subordinate to the will of "the people," which in the Soviet Union coincides with the state. The individualism of the modern age is thereby also excluded, as is traditional Christian concern for individual salvation independent of social obligations. If in official publications this ideology is expressed in a fairly balanced and moderate (although increasingly candid) form, in unofficial and quasi-official circles it is quite militant and has in many cases assumed an openly nationalistic and violently anti-Semitic tone, for in the final analysis those who brought the fiendish curse of the nihilist devils to Russia are identified as Jews, and the Revolution is regarded as part of the global Jewish conspiracy striving for the "spiritual and physical extermination of the Russian people." This ideological soil has lately nurtured such frankly pogromist organizations as the "Patriotic 'Pamiat' [Memory] Association," whose relationship to the authorities may be judged not only by the facts that it is practically the only "informal association" that has managed to become registered in numerous cities and that its leaders and sympathizers occupy positions in the official cultural apparatus which greatly facilitate the spread of its propaganda, but

also by the treatment accorded one of its leading ideologues. This man—who, incidentally, is an Arabist and former high-level government interpreter—was released after only a brief imprisonment for the brutal murder of his wife and presently lectures unhindered in central Moscow.

Whereas the village prose writers have led the crusade against industrial progress and "consumerism" and for the conservation of nature and historical monuments, many writers and artists of the post-Stalin period have seemingly made a real attempt to resurrect avant-garde traditions in an "unofficial culture" opposed to the official one, which places a taboo on any formal experiment that frees the artistic word or image from the direct service of ideology. The official Soviet cultural consciousness is more inclined to accept the "anti-Soviet realism" of a Solzhenitsyn than a fundamentally anti-ideological "formalism."[1] Unofficial art, which for years continued to develop even though it was constantly harassed by the authorities and was almost completely cut off from its potential audience, did much to raise the standard of contemporary Russian art. At the same time and despite its formal achievements, however, it can by no means be considered a continuation of the avant-gardist impulse. Quite to the contrary: this art is thoroughly retrospective, aspiring not to overcome the traditional role of the artist, but to return to it by creating impenetrable, autonomous artistic worlds, each of which claims to possess the ultimate truth about the world. Thus the single utopia of the classical avant-garde and Stalinism has been replaced by a myriad of private, individual utopias, each of which, however, is thoroughly intolerant of all the others and especially of the people and the 'socialist realist kitsch" in which the people live. This pseudoaristocratic attitude, however, ignores the fact that it reproduces in miniature the absolutist ambition of socialist realism, so that each idol of this profoundly elitist culture is a kind of Stalin to its circle of worshippers. If the "village" writers blame the destruction of Russia on the early twentieth-century intelligentsia elite, the modern heirs of this elite have by no means forgotten the brutal pogroms of the Revolutionary years aimed mainly at

the intelligentsia, the summons to kill anyone who wore "spectacles and a hat" and spoke correct Russian. Nor have they forgotten the systematic destruction of the educated classes under Stalin and the anti-Semitic "doctors' plot" near the end of his reign, not to mention the many years of discrimination based on social and ethnic origins. This entire period dug such deep abysses between the various strata of the Russian population that practically all groups are still exclusively occupied with settling accounts. For this reason, the post-Stalin rebirth of turn-of-the-century modernism has also, quite contrary to the original orientation of this culture, been retrospective, conservative, elitist, "antipopular."

The parallel between the conservative village prose writers and Stalinist culture, however, is even more obvious. Their aspiration to return to the past and resurrect what they imagine to be the "Russian" humanity and recast contemporary *homo sovieticus* in its image is, of course, thoroughly utopian. Another feature this utopia shares with Stalinism is its traditionalism, and even its nationalistically tinged environmentalism immediately recalls Stalin's "greening" campaign as treated aesthetically in Leonid Leonov's *The Russian Forest*, a novel the contemporary zealots of the Russian forest would just as soon forget. The ecological-nationalist utopia remains a utopia in the most immediate Stalinist sense of the word: once again it is a question of totally mobilizing modern technology in order to halt technological progress, put an end to history, and, by manipulating the natural human environment, change humanity itself, that is, transform the modernist and technological individual into an antimodernist and nationalistic ecologist. Postmodernism regarded as antimodernism is a resurrection of the same old modernist project of achieving a total "harmonious" organization of the world through a "self-imposed" halt. The victory of the "Russian national revival" would merely mean spinning an all too familiar record—new words sung to the same old tedious and worn-out melody.

Thus the attentive observer of the Soviet cultural scene in the 1960s and 1970s gradually became aware that all at-

tempts to overcome Stalin's project on either the individual or the collective level resulted in fateful reproductions of it. In the West, the march of progress is "aimless"—one fashion succeeds another, one technological innovation replaces another, and so on. The consciousness that desires a goal, meaning, harmony, or that simply refuses to serve the indifferent Moloch of time is inspired to rebel against this progress. Yet the movement of time has resisted all rebellions and attempts to confer meaning upon, control, or transcend it. Since the social powers that be are the servants of this superhuman power of time, therefore, Western intellectuals have always for the most part felt they were opposed to them. In the Soviet Union, however, the situation is precisely the opposite. There the only way progress can occur is through an attempt to halt it—as a nationalist reaction to the monotonously unbroken superiority of the West, as an attempt to escape this sphere of domination, that is, to flee from time into the apocalyptic realm of timelessness. Contrary to the widespread notion of its "Westernism," the Russian avant-garde was extremely nationalistic. One of its founders, Benedikt Lifshits, even speaks of its racism.[2] In any event, there is more than enough hatred of the West in the works of the Russian avant-gardists, for it is the West that incarnates the irrational progress they wanted to halt through their unified artistic plan. In general, Russian elitist nationalism tends to take the most radical Western fashion, radicalize it even further, and then claim overwhelming superiority to the West. This strategy was applied already by the Slavophiles, who similarly radicalized Schelling, by the late nineteenth-century "Russian religious Renaissance," which radicalized Nietzsche, and so on. And this nationalist reaction, which appropriates Western progress only to defeat it with its own weapon, unites the state and the intelligentsia in a profound complicity that would be impossible in the West.

Russian postutopianism, which in an ironical travesty of "sots realism" is sometimes also referred to as "sots art," has its roots in an awareness of this complicity, in the discovery of the will to power in the seemingly oppositional artistic pro-

ject, and a realization of the role the artistic project plays in the strategy of political coercion. For Russian artists and intellectuals this discovery has represented a loss of artistic innocence. Doubt has been cast not only upon the artistic will to accomplish the project, the will to "master the material," but also upon the will that rejects the project in the illusory aspiration to return to the individual or collective past. The goal now is to analyze this aesthetico-political will to power, which artists acknowledge to be primary in all artistic projects including their own.

Below I shall consider a few typical examples of such an analysis taken from the works of various artists and writers representing Soviet postutopianism, if one can apply such a label to a movement based on an awareness of the fundamental similarity between the modernist and postmodernist projects, that is, the similarity between "making" and "overcoming" history. Again, as in the analysis of the avant-garde and socialist realism, this examination does not claim to be an exhaustive treatment of the subject, but will instead attempt to focus on the basic conceptual schemes of sots art, illustrating them with examples that are truly relevant to its self-definition. Henceforth this art will be referred to as postutopian, first of all, to distinguish it from both the utopian art of the avant-garde and Stalinism and the antiutopian art usually associated with the postmodernist situation, and second, to underscore the tendency of sots art not to criticize modern progress, but to reflect utopian ambitions to halt it.

THE LOST HORIZON

Among the first works of this new postutopian art is a painting that contributed greatly to its emergence—Erik Bulatov's *The Horizon* (1972).[3] In the somewhat estranged, hybrid manner of socialist realist photography, it shows a group of people in typical Soviet dress walking along a beach toward the sea and the horizon. The line of the horizon, however, cannot be seen, because it is covered by a flat Suprematist form that seems to be superimposed on this conventional picture, cutting hori-

zontally across its entire breadth. Upon closer examination this form turns out to be the ribbon of the Order of Lenin.

The movement toward the sea and the sun is an allusion to the optimism of the socialist realist art of the Stalin years. The figures in the picture are also dressed in the typically modest, prim manner of the time, but unlike the standard Stalinist painting, there is nothing festive about this group, who also have their backs turned to the viewer. The faces of the "new people" are thus not visible, and the entire photographically realistic "Western" style of the work imparts a certain sense of alarm to its entire composition. The ribbon of the medal that covers the horizon seems to obstruct the movement of the group and bring it to a halt. At the same time, because it is simply superimposed on the painting, it can also be interpreted as signaling to the viewer the fictive flatness of the work, destroying the spatial illusion created by the movement of the group and the meticulously realistic construction of perspective.

The topos of the horizon figures significantly in the thought and practice of the Russian avant-garde. Because it retreats as one approaches it, it has long symbolized the illusion of human ambition and "progress"—humanity's temporal ontological prison. The horizon represents the limit of human possibilities, a boundary that cannot be crossed simply because it does not remain still or block the way; its very mobility renders movement a senseless treading in place, a continual reproduction of one and the same initial situation. It is no coincidence that one of the key texts of the modern age—Nietzsche's story of the death of God—associates this death with a disappearance of the horizon which evokes at once ecstasy and the terror of freedom:

"Whither is God," he cried. "I shall tell you. *We have killed him*—you and I. All of us are his murderers. . . . Who gave us the sponge to wipe away the entire horizon? . . . Whither are we moving now? Away from all sins? Are we not plunging continually? Backward, sideward, forward, in all directions? Is there any up or down left? Are we not straying through an infinite nothing? Do we not feel the breath of empty space?[4]

If for Nietzsche the "cosmic experience" of losing the horizon is still full of alarm, Malevich proudly proclaims:

> I have destroyed the ring of the horizon and got out of the circle of objects, the horizon ring that has imprisoned the artist and the forms of nature.
> This accursed ring, by continually revealing novelty after novelty, leads the artist away from the *aim of destruction*.[5]

By destroying the horizon the artist attains the absolutely new that is at the same time eternal and true, and is spared the captivity of the deceptive novelty of earthly things. Malevich experiences the disappearance of perspective and the rejection of illusory three-dimensional space as a release into the freedom of the boundless cosmic space of infinite nothingness.

What Malevich felt to be an escape into the eternity beyond the three-dimensional illusion, however, is regarded by the modern viewer as a two-dimensional plane. Bulatov writes: "Malevich simply forbids space. He abolishes it by outright revolutionary decree." Hence, he continues, the constructivists' "replacement of the space of art by the space of society. For the first time, art set society as its final goal, and society killed it."[6] Consequently, to Bulatov suprematist form— Nietzsche's sponge—imprisons rather than liberates, for its inhuman pretensions both block human movement in human space and render this space two-dimensional and flat. Malevich's "suprema" is not simply quoted but is decoded ideologically when it is made to coincide with the highest honor of the Stalin era. By symbolizing the victory of social space, the Order of Lenin, so to speak, concretizes Malevich's "abstract" geometric forms.

In other works Bulatov develops further this same device of combining the illusionary three-dimensional realistic picture and suprematist flatness. Sometimes the latter is introduced by a poster (as in *Krasikov Street*, which essentially reproduces the composition of Malevich's *Black Square*, except that in place of the square there is a poster of Lenin, and instead of white space there is a Moscow street scene, again with people moving away from the viewer toward the poster); sometimes

it is shown with a slogan such as "Glory to the CPSU!" or "Welcome." In such cases the ideological slogan or the poster serve to "reduce space (that is, living space) to a plane" destroying the perspective of the two-dimensional characters in the picture. This space-reducing function is underscored even more in works such as *I Live and See, I am Going*, and others, where the text, since it is itself placed in perspective and is moreover that which compositionally, as it were, first opens the perspective, plays the compositional role of a "spatial support." Such space-opening texts are usually in the form of "nonideological," "positive" poetic, or religious discourse.[7]

Thus as he returns to the traditional three-dimensional illusion and the realistic painting, Bulatov no longer trusts its immediacy or "naturalness." In a world saturated with ideology, neutrality becomes impossible, and the artist cannot step out of the role of the demiurge who opens or closes reality: the space of life proves to be an ideological sign, and decisions are for the most part made outside reality. Although it may appear to be such to the superficial "postmodernist" eye, Bulatov's art is anything but "eclecticism" seeking to quote the styles of various historical periods. What he instead attempts to demonstrate is the internal logic connecting these styles, not excluding his own art. Although he does not wish to be a demiurge and ideologue, he is aware that he is precisely that. Rather than reject the role that has been imposed upon him, he analyzes it from within, demonstrating the transitions from the visual image to the ideological manipulation of the image and vice versa. The disappearance of the horizon has brought with it not liberation but the necessity of continually creating it anew.

THE AVANT-GARDE ARTIST
AS THE "LITTLE MAN"

Another early manifesto of the new current is Il'ia Kabakov's album series *Ten Characters* from the early 1970s. Each album consists of a folder of pages which, when turned in order, tell the illustrated story of the life and death of one

person.[8] These illustrations register what the characters see with their "inner eye," while the texts represent external circumstances as seen through the eyes of others and told in their voices (it is impossible to say whether the work is an illustrated text or an annotated illustration).

The visual image in each album gradually disintegrates, evolving toward the "loss of horizon," a blank white sheet symbolizing the death of the person. The inner will of the character is focused on overcoming everything external and visible, on achieving the absolute suprematist nothing, complete liberation from the prison of the world. Always corresponding on the external level to this effort is the trivial story of the gradual death of a downtrodden little man—the typical hero of nineteenth-century Russian philanthropic literature. In brief, here is Malevich as Akakii Akakevich, striving for absolute white and perishing in the undertaking much as Gogol's hero yearned for the expensive overcoat unbefitting his rank. Moreover, to demonstrate their triteness and repetitiveness from within, the inner visions of the heroes are executed in the manner of "bad" Soviet art.

Thus beyond the absolute nothing of suprematism opens an even deeper abyss: the endless variety of possible interpretations of this ultimate artistic act. These range from the most profound to the most trivial, but together they deprive the act of the significance accorded it by the canonized history of the arts, which in the age of modernism became a new myth that conferred heroic and definitive meaning upon all the deeds of its heroes. Kabakov breaks this myth down into a myriad of intersecting, mutually contradictory, diffuse, trivial stories that offer no criteria for choice. Thus in *Primakov Sitting in the Closet*, for example (which, incidentally, begins with Malevich's *Black Square* as the view presenting itself to a little boy sitting in a closet), the gnostic wandering of the soul among the worlds and ages is equated with both the history of avant-garde art and the family melodrama.

At first glance, Kabakov's albums and his later larger works elaborating on certain themes from the albums all describe the triumph of the everyday over the avant-garde, which regarded

overcoming the everyday as an even more fundamental goal than victory over traditional art. If beyond the external stability or "visible horizon" of everyday life the avant-garde saw the great yawning abyss of Nothing, the absolute black of the universe, Kabakov places this vision in an everyday context. He views everyday life not as a set of stable forms, but as interwoven images, discourses, ideological attitudes, styles, traditions, and revolutions against traditions, all of which eternally comment upon each other and lead to an even deeper opacity and an even more complete absurdity than the blackness and absurdity of the avant-gardist universe, which at least has nothing as a kind of referent. In Kabakov's world there is no such stable referent—even nothing becomes something, so that radical negation is no longer possible. Noting the connection between his treatment of the everyday and the tradition of Marcel Duchamp and pop art, in his reminiscences of the 1970s Kabakov defines his position as follows:

"Ready-made," the dragging of objects from "lower" reality into galleries and museums, began early in the century with Duchamp and has since become an ordinary, quotidian phenomenon. So no "discovery" has been made here at all. There is, however, one little detail or nuance. . . . When shown in museums—even in an absurdist manner—natural objects express certain special, sometimes even vital aspects of "being"; "pop art" shows advertisements of something, and corresponding to these "display windows" there is something "inside" the store—such works advertise or promise "something real," something that really exists. Our advertisements, summons, explanations, instructions—and everyone knows this—do not correspond to anything, ever, anywhere in reality. These are pure, wholly self-sufficient utterances, TEXT in the precise sense of the word. This TEXT, which everyone knows is addressed to no one, signifies nothing, corresponds to nothing, nevertheless means a great deal *in itself,* so that interest, attention, work with this text is what constitutes the peculiarity of our production. . . . This is all the more important in view of the fact that the text permeates our entire life . . . , but it would be inadvisable to think that these texts are directed to a human subject or

address the "Soviet individual." Our art is even more unique than it appears at first glance. *Our texts address only texts*, and every text is a text responding to some preceding text.[9]

Thus under the Soviet conditions that arose during the Stalin period, everyday life coincides with ideology. In this sense the everyday really has been overcome, for it has become an "inhuman" text in which "life" has dissolved and disappeared. At the same time, however, ideology as concrete discourse addressing human beings has dissolved in the everyday: the everyday and ideology have coincided in the endless Text. These comments by Kabakov, which he made before he became acquainted with Derrida's philosophy (he refers to Wittgenstein in this article), obviously parallel Derrida's description of the postmodernist situation. Kabakov's notion of "text" corresponds precisely to Derrida's "writing" (*écriture*) in which a written text, a visual sign, is simply a "trace" that has no external referent and enters into the endless play of differences in which all stable meaning disappears. This similarity becomes even more apparent in Kabakov's use of the notion of "voice." In his works the texts are as a rule definite, named "voices," but these voices are distributed—"spaced" (cf. Derrida's *espacement*)[10]—over the space of the work, and, as "living" voices they are subordinated to compositional linkings of "dead" letters and signs. We may also note the role Kabakov assigns to drawing "on the margins" ("*po kraiu*"),[11] which corresponds to Derrida's *parergon*.[12] Analogies could also be made with the ramification of a single dominant discourse into many individual ones in Lyotard, and with the relationship between the symbolic and the imaginative in Lacan.

As Kabakov himself observes, these many similarities to French poststructuralism probably derive from a common orientation to the ideological type of discourse as distinct from the orientation to the purely visual typical of Anglo-American pop art (including its modern variants, which often illegitimately appeal to the authority of French thought of the 1970s). Despite all such parallels, however, Kabakov's Soviet postutopianism also exhibits some significant differences. Although the *parousia* or immediate "presence" of the suprema-

tist revelation expressed as "pure white" is rejected by Ka-
bakov in the name of the "text," which has to do with the
ambivalence of presence/absence, this text—like the "unartis-
tic" text that is simply written on a sheet of paper—is never-
theless situated on a white background and is rendered visible
by this background.[13] This ambivalence of text and back-
ground goes beyond "intratextual ambivalence," since the
background cannot be regarded as a simple "absence" of text.
The coincidence of the everyday and ideology signifies not
only the defeat of the avant-garde but also its victory—with-
out its "white" there would be no text upon the white. And if
the avant-gardist is a "little man" immersed in ideologized
everyday life, each little man experiences his own discovery of
the pure light of death and the absurd (rather as in Tolstoi's
The Death of Ivan Ilich, for example). Absolute *parousia*, or
the total presence of subjectivity in the single universal sense
of everything and the fullness of life, on the one hand, and, on
the other, the infinity of the text, the absence and death con-
tained in its materiality, are in Kabakov not diametrically op-
posed but function as two equally legitimate interpretations of
what is essentially a single creative act coinciding with the
"biography" of the artist.

This explains the repetitiveness of Kabakov's albums, all of
which tell the same story, which is indifferent to the basic dis-
tinction that contemporary thought draws between ideology
and reality. This story remains identical regardless of whether
it is regarded in a traditional "idealistic" spirit as a tale about
the origin of subjectivity, or as a story about the workings of
social or sexual forces, or the play of signifiers, or, if you will,
about a program run through a sophisticated computer. The
world of the endless ideological text is not in absolute opposi-
tion to the artist, for because Kabakov's artistic memory re-
members how he was "made" in the Stalin era, he is unable to
regard this world as if it were something totally external in
which he, as this concrete subjectivity, could completely dis-
solve. Long training in the world of socialist realism has
taught the artist not to draw a rigorous distinction between
the "demiurge" or "new individual" and the "cog in the ma-

chinery," its "cadre that decides everything." For Kabakov, whether the creative act is authentic or inauthentic is secondary to how the act is performed; that is, it is merely an ideological question. Just as Kant was led by his antinomies to refuse to interpret the nature of the external world, Kabakov in his works and commentaries declines to judge the nature of his inner world, contrasting to the "ontological difference" of Heidegger and poststructuralism his indifference both to all possible interpretations and to the impossibility, infinity, and so forth of interpretation.

Stalin's Best Pupils

Bulatov and Kabakov work above all with the everyday symbolism of the new Soviet life and its hidden mythology. In contrast, Vitalii Komar and Aleksandr Melamid turned in the early 1970s directly to the Stalin myth and the high Soviet classics. It was they who proposed calling their work "sots art," a term that is now used to refer to the entire current they represent.[14] Especially useful to an understanding of their views on the history of Russian art is their illustrated historical parable, *A. Ziablov* (1973). The hero of the tale, which is written in the style of a scholarly article with references to documents, eyewitness accounts, correspondence, and so on —all fictitious, of course—is Apelles Ziablov, an eighteenth-century artist and simple serf who began painting abstract art in this early period. Samples of his painting in the massive frames of the time are appended. Rejected by the uncomprehending Academy and forced to copy antique pictures, he finally hanged himself in despair. The authors seem at first to identify with the hero. After all, they were also once rejected as "formalists" by the dominant academicism, and like Ziablov they were subjected to police coercion intended to suppress in art anything "not encountered in Nature, or which, if encountered, does not correspond thereto and which without particular necessity is by certain persons employed solely to demonstrate disregard of the rules."[15]

In what is an obvious allusion to the consciousness of the

Russian avant-garde, however, it soon becomes clear that Zia-blov's abstract art—portraits of "His Majesty Nothing," whose authenticity is confirmed by the artist's dream of an apocalyptic catastrophe—is intended to adorn the torture chambers of his master, the landowner Struiskii. The fact that Struiskii is portrayed as an enlightened Westernizer integrates abstract art into the context of the state's traditional use of "Asiatic" violence to force the people onto the European road of development. Here there is also an obvious allusion to the Russian avant-garde's association with Revolutionary violence in general and the Cheka and GPU [secret police] in particular. The parallel is further reinforced by the biographer's note that Ziablov's art was typical of "the early period in the emergence of the Russian national consciousness, when the creative powers of a people awakened from their deep slumber by the great Peter began to seethe and surge."

Quite in the spirit of Stalinist historiography, we see the nationalist myth taking shape out of the history of Russia's Europeanization. The biographer maintains that "Ziablov's art arose as a protest from the depths of the popular soul against the hypocritical morals of those who would imitate the 'London atheists.'" He goes on to speak of

> the great artist's life-affirming art, which draws its inspiration from the window-frost patterns of folk art, the ever-changing hues of the sea and the sky of Central Russia, the boldly flickering flame, and the rich plastic potential of cuts of ornamental stone, for imitations of which the Ural master craftsmen are so renowned.
>
> . . . Centuries later, the tragic fate of the serf artist Apelles Ziablov, whose optimistic works have at last assumed an honored place among the treasures of world culture, shines on as a lodestar to all representatives of the creative intelligentsia seeking to achieve a typical reflection of reality in its revolutionary development.[16]

This brilliant parody of the sentimental ideological style and nationalist rhetoric of Soviet art history puts Apelles Ziablov, and with him the art of the Russian avant-garde, in the

context of the innumerable stories during the Stalin years about simple self-taught Russian serfs who outstripped the West in all disciplines and remained unknown only because of the "scheming tsarist bureaucracy," which was made up of foreigners or worshipped everything foreign. These tales, which accompanied the anti-Semitic "struggle with cosmopolitanism" of the late 1940s and early 1950s, are even today favorite targets of intelligentsia humor, so that Komar and Melamid commit an act of real sacrilege when they treat the tragic myth of the Russian avant-garde on the same level as this vulgar, kitschy subject.

Komar and Melamid themselves, however, perceive no sacrilege whatever here, because they consider the religion of the avant-garde to be false and idolatrous. The key to their own view of it is to be found in Striuskii's remarks to Apelles, in which he writes that he does not understand the spirit of Ziablov's iconoclasm, because it is not taken to its logical conclusion: "Would it not be preferable to rely upon a stark style, as do the Jews of yesteryear and today? And why should the goal be struggle with these rather than other idols?"[17] The avantgardist, Stalinist, Westernizer, and Slavophile myths are constantly interlacing, recoding, retelling one another, for they are all idolatrous myths of power. The pseudoiconoclastic avant-garde myth of "nothing" manifested as the solemn portrait of "His Majesty Nothing," therefore, can become the solemn portrait of anyone, including Stalin.

The central impulse in Komar and Melamid's works comes from this fundamental intuition that all art represents power. Proceeding from this insight they abandon from the outset the search for a form of art that can resist power, because they regard such a quest as itself a manifestation of the will to power. Their strategy is to show that the same myth of power—artistic and political at one and the same time—pervades all world art, not excluding their own. They candidly declare their ambition to become the greatest and most famous artists of the century, thereby creating a kind of simulacrum of the genius-artist. As the model for their absolute cult of the artistic personality (the irony in their treatment of it is

evident in the very fact that there are two of them), Komar and Melamid take Stalin, who since the late 1970s has become practically the central figure of their art.

Not only do the artists not "unmask" or "demythologize" the Stalin myth in these works; on the contrary, they "remythologize" it, praising Stalin more vociferously than any artist of the period would have ventured to do. At the same time their eulogies transform Stalin into an element of a kind of surrealistic dream executed in the academic style. Their paintings are, as it were, a session of social psychoanalysis that retrieves from the Soviet subconscious a mythology whose existence no one is prepared to acknowledge even to themselves. Censorship has many strata—there is the "liberal" censorship of everything connected with official Stalinist symbolism, the Stalinist censorship of everything individual, "decadent," "immoral," and "Western" and the related, typically Soviet censorship of everything "erotic"; the prototypes of the sacred figures of Russian history outside the country are also censored, since the existence of the former undermines the uniqueness of the latter. Beneath all this censorship there has accumulated in the subconscious of the Soviet individual numerous strata of associations and inner moves linking the West, eroticism, Stalinism, historical culture, and the avant-garde into a single mythological network. Komar and Melamid's psychoanalysis is more Lacanian than Freudian. They do not attempt to reveal any specific individual trauma incarnated in a specific historical event, but allow the signs of different semiotic systems to commutate, combine, become juxtaposed, and so on in order to uncover as much of the net of associations as possible in all directions and on all levels. As a result, ossified Stalinist mythology is set in motion and begins to exhibit its kinship with innumerable other social, artistic, and sexual myths, revealing as it does so the eclecticism it has concealed even from itself. Freeing the Stalin myth from its static fetters also frees the artist and the viewer from the myth. Rather than negating the myth, however, this liberation expands it beyond the reach of the power it initially derived from the building of socialism in one country. The myth of Komar

and Melamid is richer and more varied than that of Stalin, which is still bound to its modernist claim to exclusiveness. These best pupils of his are rescued from their teacher by the fact that they simulate a project that is even more grandiose than his.

Komar and Melamid, therefore, regard their "sots art" not as a simple parody of socialist realism, but as the discovery within themselves of a universal element, a collective component that unites them with others, an amalgam of individual and world history. The latter is symbolized not least by the Yalta accords, which consolidated the division of the world into two blocs, each of which is the other's "dark side"—its "other," its "subconscious," its simultaneously utopian and negative phantasmas.[18] This division, which is what led the artists to turn toward the West as long as they were in Moscow, and, conversely, to attempt to reconstruct their "Eastern traumas" after emigrating to the West, thus coincides with a kind of unstable boundary between the artists' own conscious and subconscious selves, which therefore constantly switch places, depending on whether the Western or the Eastern perspective is chosen.

In their work *The Yalta Conference*, Komar and Melamid create a kind of icon of the new trinity that governs the modern subconscious. The figures of Stalin and E.T., which symbolize the utopian spirit dominating both empires, reveal their unity with the national-socialist utopia of vanquished Germany. It should be observed here that in all their art Komar and Melamid proceed from this inner kinship between the basic ideological myths of the modern world. Thus in one interview Melamid maintains that the common goal of all revolutions is "to stop time," equating in this respect Malevich's *Black Square*, Mondrian's neoplasticism, Hitler's and Stalin's totalitarianism, and Pollock's painting, which "generated a notion of individuality beyond history and time; powerful as a tiger, it will destroy everything just to be left alone. It is a very fascistic conception of individuality.[19] Thus in American life and art as well (E.T. is an aptly chosen symbol) Melamid perceives this spirit of extrahistorical utopia hostile to con-

stant change and the flow of time itself. True, in the same in-
terview Komar is more cautious, distinguishing "Stalin's" rev-
olution from Trotskii's permanent revolution, which moves
together with history and does not set itself any ultimate
goals. It may be said that for these artists, history itself moves
through the attempts that are made to stop it, so that each
movement contains a utopian potential that pushes history
ahead and at the same time blocks its progress. Thus utopia is
not merely something that must be overcome or once and for
all rejected—such a course would itself be utopian—but an
ambivalence that is intrinsic to all artistic projects, including
the antiutopian ones, which should be reflected through a so-
cial psychoanalysis that does not distinguish between self and
others, between personal and political history.

In the formal respect, the Soviet postutopian art of the
1970s is characterized above all by a renewed narrativity that
runs counter to the avant-garde rejection of literariness and
instead continues the narrativity of socialist realism. Here, as
in the case of Stalinist culture, it is least of all a question of a
simple return to the pre-avant-garde depiction of morals and
manners. Beneath the pure and ultimate gesture of the classi-
cal avant-garde has been discovered the avant-garde myth
without which this gesture cannot be understood and quite
simply cannot even be made, namely, a legitimizing narrative
in the form of an ideologically structured modernist history of
the arts that tells how the artist was gradually liberated from
narrativity. This myth, which is in the West generally regarded
as self-evident, was naturally questioned in post-Stalinist Rus-
sia, because there it was juxtaposed with the rival Stalinist
myth of the "positive hero," the "new man," the demiurge of
the "new socialist reality." Between these two obviously mu-
tually exclusive myths there immediately appeared—to use
Wittgenstein's term—a "family likeness": The story of the sol-
itary and suffering avant-gardist hero who renounces the past
and finally triumphs over the stagnant world—a story that
describes both the ontogenesis and the phylogenesis of mod-
ernist art—turned out to be the identical twin of the hagiogra-
phies of Stalinist five-year plan heroes such as Pavel Kor-

chagin, who was the model for an entire generation of Soviet youth.

What the sots artists have thematized more than anything else is this hidden avant-garde narrative, this myth of the artist as creator, prophet, and engineer. Using the devices of Stalinist indoctrination, they have attempted to demonstrate the similarity of this myth to those of both the present and the past in order to reconstruct the single mythological network in which the modern consciousness functions. Naturally, this return to narrative could not fail to attract the attention of writers who were previously frightened by the avant-garde's struggle with all narrativity and shocked by the destruction of the narrative aesthetics of the Stalin period. Somewhat later than in the visual arts, there appeared in the late 1970s and early 1980s a number of literary works that reflect the new cultural situation, and it is to a discussion of a few of these that I now turn.

POET AND MILITIAMAN

The first writer to take a radical postutopian position was the sculptor and poet Dmitrii Prigov, who, like Kabakov and Bulatov, has become something of a cult figure among the Moscow intelligentsia. In his well-known cycle of poems on the militiaman, Prigov in effect identifies—or rather, he plays with the possibility of identifying—the power of the poetic word with that of the state. The militiaman is portrayed as a Christ-figure who unites heaven and earth, law and reality, divine and human wills:

> When the Militiaman stands here at his post
> He can see all the way to Vnukovo
> The Militiaman looks to the West, to the East—
> And the empty space beyond lies open
> And the center where stands the Militiaman—
> He can be seen from every side
> Look from anywhere, and there is the Militiaman
> Look from the East and there is the Militiaman

> And from the South, there is the Militiaman
> And from the sea, there is the Militiaman
> And from the heavens, there is the Militiaman
> And from the bowels of the earth . . .
>
> But then, he's not hiding[20]

Prigov draws upon the Soviet poetic mythology of the 1920s and the Stalin years, from Maiakovskii's glorification of the militia in *Good!* to Sergei Mikhalkov's kitschy children's poem, "Uncle Stepa is a Militiaman":

> The Militiaman strolls through the park
> One late autumn day
> And high above his head
> Is the pale sky in a portal arch
>
> And there along the path
> He sees so clearly a future
> When people have become so sensible
> That his job will disappear
>
> When his uniform is no longer needed
> Nor his holster and revolver
> And everyone lives in fraternity
> And everyone is a Militiaman[21]

This borrowing is anything but ironic, however. Prigov is aware that his own ambition to capture the souls of others through poetry is inherently related to the myth of the militiaman, in whom he recognizes his more successful rival for blessings from on high:

> In the restaurant at the Writers' House
> The Militiaman drinks his beer
> He drinks in his usual way
> Not even noticing the writers
>
> But they look at him—
> Around him all is bright and empty
> And all their sundry arts
> Mean nothing when he is around

He represents Life
Clad in the uniform of duty
Life is short, Art long-lived
And when they clash, Life wins[22]

The poetic impulse as the aspiration toward the "ideal,"
toward "harmony" that arouses "kind feelings," is from the
outset a manifestation of the will to power, and the poet rec-
ognizes his double in the image that would appear to be the
most foreign to him, even his opposite. This recognition, how-
ever, does not imply that Prigov resorts to anarchy or the dis-
cordant aesthetics of protest to express his opposition. This
strategy has already been tried by culture, and it has been
shown that the original poetic intent, since it is meant to act
upon the soul, the world, or at least language, inherently ap-
peals to divine order even when it appears to be denying it:

Once the Militiaman met the Terrorist
And said to him: you are a terrorist
An anarchist of discordant spirit
While I am harmony in this world

The Terrorist retorted: But I love Liberty!
Liberty, and not what you call freedom!
Go away, don't block the entrance!
You're armed, but I'll kill you anyway!

The Militiaman answered, aware of his
Power: You cannot kill me
You may pierce my flesh and rip my uniform
But your passion is no match for my mighty image![23]

In the clash between the anarchist poet and power, it is the
latter that wins the "spiritual victory," whereas the triumph of
the poet, the protester, the dissident, is merely "material."
This reversal of the usual rhetoric based on Stalin's transfor-
mation of yesterday's anarchists, poets, and revolutionaries
into policemen of the new world bespeaks a deeper skepticism
toward the potential and significance of the poetic word than
was conceivable in the avant-garde period. Unlike Khleb-

nikov, Prigov does not search for a pure transrational language that would grant him complete freedom from meaning and thus from external control of his poetic intent by the state, tradition, the "everyday," and so on, because in Khlebnikov's absolute claim to the magic power of his own self-proclaimed word, Prigov sees the "Chairman of the World" fuse with the militiaman, who was not for nothing eulogized by Khlebnikov's follower, Maiakovskii.

Prigov openly maintains and thematizes the kinship between poetic and political ideology and between the poetic and the political will to power. He himself often dons a militiaman's cap when he turns to his audience with appeals for kindness and decent behavior. Here the avant-gardist desire to reduce oneself and one's own expressive resources is exchanged for its opposite. Now instead we find an expansion beyond the limits of the poet's traditional role, a readiness to exploit the "family likeness" in the manner of Komar and Melamid to create a simulacrum personality cult of one's own, patterned on that of Stalin in order to slip out from under his power, so to speak, "through the back door."

Prigov also mythologizes the space of his poetico-statist cult—Moscow. His cycle "Moscow and the Muscovites" unites and reveals the intrinsic kinship of all the Moscow myths: Moscow the Third Rome ("There will never be a Fourth!"); Moscow the apocalyptic city, the heavenly Jerusalem that according to Dostoevskii unites all peoples in "beauty"; Moscow the capital of the socialist world contrasted to capitalist evil, class and national oppression, militarism and imperialism; "secret," "departed" Moscow, that is, the emigration that has saved the "true Moscow" from the Bolsheviks; underground, dissident Moscow; Moscow as the language of Moscow, the genuine poetic word, and so on. All of these apparently disparate images of Moscow have one feature in common—in all of them the city is a synonym of truth, good, and beauty, the imperial center contrasted to or ruling over the entire world. Prigov regards this central position of Moscow as natural and necessary to maintaining the centrality of his own poetic talent. He is perfectly aware that Soviet

missiles of all ranges lend his poetic word tangible additional weight—even when this word is aimed at Soviet militarism. Unlike many others, he does not wish to conceal this awareness, which means that as a poet and a self-created poetic myth he exposes himself to a more critical and searching analysis than traditional modernist demythologization is prepared to tolerate.

A CRUEL TALENT

The ideological and ambivalent nature of all poetry and the internal sameness of narratives that legitimize the artist, the poet, the politician, the ideologue, and the mystical "ruler of men's minds" are also among the subjects considered by the young and very talented Moscow prosaist Vladimir Sorokin, whose works are often distinguished by a shocking brutality and what is sometimes called the "aesthetics of the repulsive." Undoubtedly influential here are certain unofficial Soviet writers of the 1960s who attempted to oppose the optimistic, "rosy" official aesthetics by demonstrating the full ugliness of the "abyss of the human soul" and "real" life. A special place among these writers is occupied by Iurii Mamleev, whose skillfully written stories depict in a spirit even starker than Dostoevskii's the often demoniacal, "perverted" rituals by which the human soul is saved from the horrors of the world.[24]

The protagonists of Sorokin's short story "Opening Day"[25] are two hunters who comment much in the manner of the "village prose" writers on the decline of moral values among the rural population, the beauty of nature, and the despoliation of the environment. In the course of the story, however, the hunters prove to be cannibals who lure their victims into the trap with a tape recording of Vysotskii's songs. Three myths are united in the story: the nationalist-ecological, the liberal-dissident (it is in such circles that Vysotskii is most popular), and the sort of mysticism found in Mamleev. The village prose idyll is the trap, and the aura of spontaneity and authenticity radiating from a monotonously repeated tape recording of Vysotskii's rasping voice serves as the bait that attracts the

tourist intellectuals. Sorokin treats the murder itself, however, "unseriously"—it is merely a literary game not admitting of any "moral reaction," merely a stylized ritual alluding to a certain literary tradition.

Sorokin's story "Passing Through"[26] is similarly structured. A high-ranking party official concludes the approval of a local project by climbing up on a table and defecating on the plans. The ritual of the party conference passes directly into the enigmatic "private" ritual that, according to Bakhtin, alludes to the bodily lower stratum.[27] This ritual, however, fails to conform to Bakhtin's theory in that it is not carnival and does not evoke laughter—there is nothing in its emphatic seriousness and significance to distinguish it from the ritual of "high," "official" culture that preceded it. According to Bakhtin (to whom Sorokin is undoubtedly alluding), the spirit of the "folk carnival" that liberates the revelers from the official "monologic" culture is based on a sharp opposition between high and low, serious and humorous, official and popular, spiritual and bodily, and so forth. All of this is completely lost in Sorokin, who eliminates these already familiar oppositions: the rituals of "high" and "low" pass into each other and are mutually recoded in the same way as the narratives of the avant-garde and socialist realism. A chapter of Sorokin's novel *The Norm*[28] brilliantly illustrates this latter type of transition. The passage consists of a collection of letters written by an old pensioner who lives in a dacha belonging to some privileged city dwellers. It begins, as many of Sorokin's works, with an idyllic village scene quite in the spirit of the Russian neonationalists but full of moral indignation with the rich urban good-for-nothings whose garden the old man is forced to tend. This indignation gradually becomes so intense that it can no longer be expressed by ordinary words, and the old man's anger pours forth in a kind of transrational language. His letters begin to resemble the transrational texts of the Russian avant-garde, so that Khlebnikov's poetic inspiration suddenly becomes the equivalent of a kind of verbal foam on the lips of a narrow-minded philistine driven by life into a fit of hysterical frenzy.

Sorokin's combination of different styles, literary devices, myths, "high" and "low" genres is anything but a subjective game or act of individual freedom contrasting with the tyranny of "modernist discourse" and its set on the "absolute text." Nor, as was already noted, is it a Bakhtinian "carnivalization" of literature. Sorokin's combination and quotation of various types of literary discourse is not arbitrary but is intended to reveal their internal similarity. In this respect he is simply more a realist than a postmodernist. He does not mix "his own" and "someone else's" voice in carnival ecstasy to "erase the boundaries" and fuse in mystery and art that which is separate in life, but reveals the unity of the mythological network that is concealed by this division.

Characteristic not only of Bakhtin but also of many other theorists of the modernist age is an intensely experienced inaccessibility of "the other," an aspiration to breach the limits of individuality, to achieve a dialogue and even a kind of corporeal intimacy, a mixture of different languages forming a single "grotesque linguistic body." In contrast, Sorokin and many other writers of the new "postutopian" literature convey the sensation that the individual is from the outset dissolved in the impersonal or superindividual. This superindividuality, however, is not something subconscious opposed to or threatening to destroy the individual as a conscious being. Both the individual consciousness and each individual style are related to others without any violence in theory or practice on the part of the author or ideologist. The writer therefore no longer needs scandal or carnival,[29] nor does he require any collectivistic project or appeal to the universal forces of eros. The simplest description renders the deindividualization of the individual completely transparent. The problem arises instead in the attempt to separate from the other, "acquire individuality," and so on. The whole point, however, is that it is this need of individualization that is the most universal necessity uniting all of us, and that the better it is fulfilled the more I internally resemble the other. Classical modernism perceived in individuality a certain objective reality defined by its bearer's specific position in space, time, the chain of genera-

tions, and so on, so that it was a matter of overcoming this inborn individuality through "real" material forces, be these social, libidinous, or linguistic. Contemporary postutopian thought, in contrast, sees in individuation a certain strategy that in some measure is common to everyone, while in the aspiration to overcome the individual it perceives only an extreme exaltation of this strategy. Avant-garde artists attempted simultaneously to overcome the individuality given to them by tradition and to find beyond it their "genuine," hidden individuality. It is no coincidence that it was the rejection of individuality in favor of the source, the "original," that made the prophets of the avant-garde such obvious individualists and "original" eccentrics.

Chronicler of the Kremlin

Sasha Sokolov's novel *Palisandriia*[30] is a kind of family chronicle of modern European and Soviet mythology that is so rich in mythological and metaphorical associations that any conscientious commentary on it would be a laborious undertaking indeed. Fortunately, however, the task has already been partially fulfilled by the author himself, for in a sense the novel is an autocommentary. As in Greek mythology, all of Sokolov's quarelling gods of modern history are close relatives. The hero Palisandr[31] is in essence an artist, a creator abandoned in the space of posthistory, where creation is becoming increasingly impossible.

At the beginning of the novel, time stops when Lavrentii Beriia, the hero's relative and mentor, NKVD head, and symbol of Stalinist terror hangs himself on the clock of the Kremlin tower. Thus the stoppage of time coincides with the failure of Stalin's total project. It is also significant that the security police (the hero is himself an agent) should be referred to as the "Order of Watchmakers." The myth of the all-seeing police secretly directing the life of the country is a new variant of the myth of Fate or Divine Providence. The death of this myth marks the beginning of timelessness. The world of Stalin's Kremlin in which the hero grows up is described by him as

paradise. It is not the prehistorical Paradise, however, but a paradise of history in which all historical figures are bound together by intimate blood ties. The historical chronicle becomes a family chronicle in the consciousness of the artist-historian. Thus when the hero is banished from paradise he is driven not into history but out of it—to a loss of historical memory, into the everyday in which historical heroes lose their eternal youth.

Significantly, although Palisandr is related to or intimately acquainted with all of the important historical figures of the modern age—those who dominate in the West as well as those who rule in the Kremlin—he does not remember his parents. As in Plato's Utopia, in Stalin's ideal state individuals do not know their parents, although they recognize them in everyone. Palisandr therefore focuses his passion exclusively on the old women who have replaced his mother. His violation of the Oedipal taboo on the level of both his own family and the state (he seduces Brezhnev's wife Viktoriia and, seeing his father in Brezhnev, attempts to assassinate him) signifies the negation of time, the beginning of a posthistorical utopian existence in which conception is no longer possible, mothers are unrecognizable, and the paradisaical freedom of desire is absolute. The cause of the hero's banishment from this paradise, which coincides with his emigration to the West, is the project suggested to him by the KGB (Andropov personally) to restore the link of time through contact with old Russian culture in emigration, which promises to "adopt" the hero as its grandson and replace the father and the state he lost after Stalin's death with a turn to an even more remote past, thus setting time and history moving once again.

The banishment of the hero is described in terms that allude to all the myths of modern culture. According to Freud, the hero in exile looks into the mirror for the first time; according to Jung, he discovers he is a hermaphrodite; according to Marx, he is alienated in the capitalist society of the West, and so on. "Adoption" proves impossible, for the emigration is also living in the posthistorical *déjà vu* world, but the hero accomplishes his mission nonetheless. His passage through

this negative world, this alienation, this hell, confers upon him a mythical wholeness and gives him all the secrets of success. Through machinations bordering on the criminal, he amasses enormous sums of money, is awarded all the Nobel Prizes (the eternal dream of the dissident Russian writer), and finally receives an invitation to come to Russia to rule. He sets off, taking with him from the other world (the West) the coffins of all Russians born outside their native land. His triumph, however, ultimately becomes defeat: the passage of time is restored, but an infinite number of clocks all show a different hour.

Thus Sokolov portrays Stalinist culture as a historical paradise, a union of everything historical in a single myth. At the same time, the bankruptcy of this culture signifies the final defeat of history. The hero follows all the recipes of modern culture for recovering lost wholeness: through emigration into the Russian past, through the libido and anima myths of psychoanalysis, through what has been politically and sexually forbidden, excluded, and repressed, he aspires to return to history; like Hamlet, he attempts on his own to mend the broken link of time, to expand and "remythologize" rather than "demythologize" the myth in order to make narrative possible once again. The inherent unity of the historical myth, however, is in itself not historical—the utopia of the historical proves to be as impossible as the utopian dream of leaving history.

For Sokolov—and here his origins in the culture of socialist realism are in evidence—modern ideologies such as Marxism, Freudianism, Jungianism, and structuralism are not metadiscourses, not interpretative schemes for understanding literary narrative to be accepted or rejected, but are themselves literary narratives *par excellence*, the real plot structures of our time. And although these ideologies rival each other on the metalevel, on the level of narrative they display a profound kinship that unites them with all narratives of all ages and peoples. This is why in Sokolov and Sorokin they do not participate in a dialogue, oppose each other, or enter into a "carnivalistic" mixture as they do in Bakhtin, but instead go on

peacefully playing their family games, winking at each other and delighting in their family likeness. Although it is polymorphous, Sokolov's world is not pluralistic, because pluralism presupposes the incommensurability of different "points of view," "discourses," "ideologies," and so on, which are connected only by the external relations of "rational discussion" or irrational power. Claims to unite these "individual perspectives" will immediately draw accusations of totalitarianism, hegemonic ambitions, or the will to power from those who champion the "otherness" and "irreducibility" of the "other." Like many other contemporary Russian writers, Sokolov shows that the ideological pluralism of our time is in itself an illusion, an ideological construct. Contemporary "theories" may contradict each other or even be incommensurate, but their narratives are all the more similar for it. One and the same plot can tell about the artist who discovers the feminine side of his soul, the wage laborer's alienation, the KGB agent in a hostile environment, the dissident searching for the truth outside the Soviet world, and so on. They all perform the same ritual of individuation by proceeding beyond what "exists," is "usual," "traditional," and "given," and by crossing this boundary they discover a new truth, which they proclaim to humankind. To be aware of this ritual is to realize the inevitability of history and historical narrative, which can be overcome neither by a single and final flight from history into the space of extrahistorical truth, nor by the timelessness of pluralism: "historical history" consists in this very history of attempts to overcome history.

Contemporary Russian postutopian art as represented by the figures discussed above is of course in line with what is usually termed "postmodernism." Linking Russian literature and art of the 1970s and 1980s with similar phenomena in the West are a shared aspiration to erase the boundary between "high" and "low" in art, interest in the myths of the everyday, work with extant sign systems, an orientation toward the world of the mass media, the rejection of creative originality, and a great deal more. It can even be maintained that many Russian

artists have been inspired to turn to Soviet mass propaganda by the use that American pop art has made of the visual world of advertising.[32] Another such factor is familiarity with the French poststructuralism of Michel Foucault, Roland Barthes, and others.

The Russian variant of postmodernism, however, differs significantly in a number of respects from that of the West, and it is to these distinctions that I now turn. First of all, Russian postutopianism does not tend to struggle with progress. Anti-industrialism and antirationalism are more characteristic of the conservative official ideology of the "village writers," which may be defined as a nationalist environmentalism. This ideology, which worries about the preservation of the Russian people and their traditional way of life as if they were not adult human beings but so many Galapagos tortoises, is itself utopian. Like all modern utopias, it seeks to turn progress against itself, stop it with its own forces, resurrect by technological means the natural paradise that technology has destroyed. As was shown above, however, it was this aspiration to halt progress that was the initial impulse among the Russian avant-garde, and in any event it constitutes the basic spirit of Stalinism, which strove to transform Russia into a "garden city" on the basis of "genuinely popular, national traditions." Thus the nationalist-ecological utopia in Soviet Russia is too similar to the utopias of the past to seriously interest anyone familiar with recent history.

The orientation toward ending history and progress, toward a "homemade apocalypse" of the atomic or ecological variety, of course, is typical not of Western postmodernism as a whole, but only of the superficial interpretation that regards it as a new antimodernism, which in essence it is not. For Derrida, the poststructuralist, postmodernist consciousness is defined instead as the "end of the end," the impossibility of apocalypse.[33] This view is closer to that of the Russian writers, with one signficant reservation. Derrida regards consciousness as trapped in an eternal structure, which it cannot describe as classical structuralism had hoped to do. "Authenticity," "presence," "individuality" are therefore impossible: they can

never reach themselves. In poststructuralism, "difference," which prevents consciousness from reaching meaning, or in other words the gap between "ideology" and "reality," is of such a nature that it cannot be overcome. This gap can only be indicated negatively by revealing the ideological essence of thought at each stage of its development. In Baudrillard's terms, we always have to do with mere simulacra, never with things themselves.

This totality of the ideological horizon contrasted with the avant-gardist belief in the possibility of breaching it is constantly thematized in the Russian art of the 1970s and 1980s as the impossibility of breaking the closed circle of the dominant Soviet ideology. Even when "dissidents" risk their lives attempting to do so, they remain within its confines in at least two respects. First of all, they confirm the Manichaeism of this ideology, which has provided a place for its "enemy" in its structure, and second, they reproduce the emancipatory, enlightenist gesture that gave rise to the ideology and that has already found its proper place within it. Thus it is fully possible to describe the works of Erik Bulatov, for example, as attempts to indicate "difference" by covering the entire space of the work with ideological signs that are alternatives to each other but as a whole do not offer any escape. The same can be said of many other works of this period.

Still, it is impossible not to notice that the theories of difference and the simulacrum remain utopian, because they deny the categories of originality and authenticity intrinsic to our conception of history. Viewed from this perspective, postmodernism does indeed appear to be something fundamentally new and unprecedented, since it is the first to forbid and forever rule out authenticity and proclaim a thousand-year Reich of difference, simulation, quotation, and eclecticism. The spirit of this new postmodern Gospel is thoroughly theological—it is a new asceticism, the renouncement of one's own "soul" in the name of some higher principle ("Those who sacrifice their souls will be saved"). Here there is a kind of higher spiritual testimony that this world belongs to the Prince of Darkness and that the "spiritual" elect can only refer to their

election indirectly, in a spirit of negative theology (or "apophasy," as it is known in the Russian Orthodox tradition). In other words, the attitude toward the world and history remains critical, and the search goes on for a utopian escape from them through a kind of "negative utopia" that unites features of traditional utopias and dystopias.

No one reared on the official Soviet doctrine of dialectical materialism will find anything essentially new in all this. Dialectical materialism, after all, consists in the classical Hegelian relativization of all individual positions plus the "materialistic" impossibility of ultimate contemplation, of synthesis on the level of philosophical contemplation, since such synthesis is admitted only in "social practice," that is, beyond individual consciousness and consciousness in general. Hence, beginning with the Stalin years, at least, official Soviet culture, Soviet art, and Soviet ideology become eclectic, citational, "postmodern." Official Soviet art has already claimed the right to dispose freely of the heritage of the past regardless of its internal logic, so that the only essential difference between it and contemporary Western postmodern art is that the latter "appropriates" the artistic heritage individually, whereas in the Soviet Union this is done according to a centrally directed plan. In any event, in West and East alike neither the theorists nor the practitioners of quotation and simulation are prepared to address the originality and authenticity of their own position, which they are able to defend quite persuasively against all charges of plagiarism—unless, of course, such plagiarism is part of their strategy.

The utopianism of Soviet ideology consists, as it were, in its postmodernity, in the way that it bans anyone's own discourse as "one-sided," "undialectical," "divorced from practice," and so forth, which on the whole produces the same effect as postmodern criticism. Moreover, critics of the avant-garde in both East and West accuse it of being in the service of the new institutions of power controlled by the big multinational corporations and of orienting itself to the marketplace. The avant-garde in the West existed in a relatively stable social system that did not yield to its pressure and which, therefore,

in the mechanisms of the art market, the museum, and so forth, became its "context." This is the source of the postmodernist criticism that the avant-garde has closed its eyes to this context, aspiring to achieve isolated "revelations" and to "present" its contemplations without reflecting their sign functions in this relatively stable context. The initial impulses behind this critique are fully Marxian and therefore long familiar to all Soviets.

As was indicated above, specific to the Russian avant-garde is the fact that it worked not with the text, but directly with the context, the reason being that this context, which in the West seems so stable and self-evident, was in Russia disrupted by the Revolution. The artists of the Russian avant-garde did not regard their works as contemplations or revelations—they could be viewed as such only when they had been secondarily aestheticized in the Western museum—but as projects for restructuring the very context of everyday life and all its institutions, particularly those in which art was produced and distributed. And this restructuring was accomplished in reality by Stalin. In the West, the new postmodern mentality arose out of the defeat of the avant-garde and its incorporation into a context which, being external to its original goals, possessed a seductive ontological reality. In the East, by contrast, the postutopian mentality arose out of the victory of the avant-garde and a restructuring of the entire Soviet life environment under the influence of its impulse, hence the important differences that can be observed in the respective reactions to the new situation.

To summarize this distinction it might be stated that Eastern postutopianism is not a thinking of "difference" or the "other" but a thinking of indifference. Confronted by the failure of the Stalinist project to escape from world history, *homo sovieticus* at first requested readmission to history—one illustration was Khrushchev's 1960s exhortation to "overtake and outstrip America." At that moment it suddenly became terrifyingly clear to Soviet individuals how far removed they were from world history and the world context. Utopia had been transformed into antiutopia, and transcendence of the histori-

cal had become a horrible lapse, almost into the prehistorical. Precisely because it lacked a normal context, the life environment that had been created by the regime was so artificial and so manipulated that it depreciated all human feelings and thoughts, transforming them into signs of a nonexistent and superfluous language. As usually happens in such cases, however, the first shock was immediately followed by a second. At the very moment when *homo sovieticus* wanted most of all to leave the utopia and return to history, there suddenly was the discovery that history no longer existed and there was nowhere to return to. In the West that was to be "overtaken," no one was hurrying anywhere anymore; all hopes of change had vanished, because the historical perspective or orientation to the future had itself disappeared. It turned out that the utopia in which the Soviet Union had been living was the last one, and the loss its bankruptcy signified for its unfortunate inhabitants was just as great for the West.

Russian postutopian art can be interpreted as a reaction to these two successive shocks. At its core is an effort to cease being concerned about both text and context, to regard with indifference such questions as whether or not the thinking of the individual can be completely manipulated by a *malin genie*, whether this thinking is authentic, whether there is any distinction between a simulacrum and reality, and so on. To persons who have lived only in the Stalinist system and have read only *The Short Course*, their lives, thoughts, and feelings—because they are finite and because there is no external criterion by which they can be judged inferior—are just as authentic as to the inhabitant of the capitalist system. The moment we realize that Borges' Library of Babel is not unique, but that there also exists, say, a library approved by Stalin, we will no longer care which of them holds what we have written or what place it occupies there. So what if my text is merely a move in the endless play of language; even language, after all, is merely a move in my narration. It is possible to say anything in a given language, but one can also invent a new one. This language need not be comprehensible in order for something

to be said in it; but it is not necessarily incomprehensible, either.

Simplifying somewhat, it can be said that the use modern Western artists make of quotation, simulation, and the like is dictated by their sociopolitical oppositionality, their critical attitude toward a reality that they do not wish to "multiply" or "enrich" through their art. They prefer instead merely to duplicate that which already exists, to make a "zero move" they regard as neutralizing and transideological. Such a project, of course, is thoroughly utopian and merely gives rise to new artistic vogues. Russian postutopianism does not make this mistake, for it has before it the experience of official Soviet art. Although it does not reject utopia or the authentic, it regards them not as completed states but as a narrative whose similarity rather than opposition to other narratives is uppermost in its consciousness. Contemporary Russian artists or writers, therefore, no longer insist on the originality of this desire to create something original; at the same time, they do not abandon the desire in search of even greater "postmodern originality," but integrate the myth of themselves as creators and demiurges into the inherited mythology. Fully aware of the universal mythicality of their personal utopias, they all build their own socialisms in one country. Thus Kabakov says that the Russian avant-garde, sincerely believing that it was initiating a new age of social and cosmic regeneration, regarded Russia as a ritual sacrifice necessary to the process of universal transformation. Despite all their deprivations and suffering, therefore, the present in which the avant-garde artists lived did not call their faith into question. Only the Russian past and the past in general were for them the paradise that was to be resurrected in the future, so that in their utopian euphoria and ecstasy the present was merely a magnificent sacrifice of the national and individual. Kabakov goes on to say that the Russian avant-garde simply never understood "the full boredom of the untold centuries of pharaohs and czars so-and-so the first and so-and-so the second," the endless boredom and monotony of the past that became the real

future in the "postutopian universe" surrounding us now. Yet at the same time, he observes, "here in Russia the collapse of the great utopia didn't really mean the total collapse of all utopian thinking." Noting further that his own art also describes these private, "imperfect utopias, small feasts, small illusions about reality, fragments of paradise in the everyday," he states that "shaking free of little utopias is hardly less frightening. It's rather like having slain some great huge animal and then discovering that you still haven't dealt with the rats."[34] The thousand-year boredom of the everyday of which Kabakov speaks is the tedium of the thousand-year utopia. And the millennial kingdom from which many in the modern age want to escape is in turn a utopian project, a hope for fundamental change. Living with utopias as with rats, the artist's only consolation is to organize rat hunts.

DESIGNERS OF THE UNCONSCIOUS
AND THEIR AUDIENCE

THE BRIEF consideration of the Russian culture of the pre-Stalin and post-Stalin periods presented here enables us to define more precisely the nature of Stalinist culture itself. Stalinist culture brought out into the open the myth of the demiurge, the transformer of society and the universe, which, although it was presumed by the avant-garde, was not explicitly expressed in avant-garde artistic practice, and it set this myth in the center of its entire social and artistic life. Like the avant-garde, Stalinist culture continues to be oriented toward the future; it is projective rather than mimetic, a visualization of the collective dream of the new world and the new humanity rather than the product of an individual artist's temperament; it does not retire to the museum, but aspires to exert an active influence upon life. In brief, it cannot simply be regarded as "regressive" or pre–avant-garde.

At the same time, Stalinist culture is interested above all in the creator of this new utopian world, who in the art of the avant-garde remained outside the project he had created in "the present," which was merely a prelude to the future. In this sense the avant-garde may be said to be "Old Testament": its God transcends the world he has created, and the prophet does not enter the Promised Land. Stalinism overcomes this excessively one-sided iconoclastic spirit and makes a new icon using the realistic devices of secular painting. Socialist realism does not need stylizations of historical icons or the classics of antiquity, because it is based upon the thesis that sacred history takes place here among us, and that the gods and demiurges—Stalin and his "Iron Guard"—constantly work

their world-transforming miracles in the here and now of the everyday.

It is for this reason that the "realism" element of socialist realism is so deceptive. It is merely a means of indicating the contemporaneity, novelty, and relevance of a demiurgic process of transformation which, although it is clothed in visible symbols, for the most part takes place outside the visible world. In this sense, Stalinism, like Christianity, liberates the inhabitants of utopia from blind obedience to the laws handed down by unseen creators—Malevich, Rodchenko, Khlebnikov, and others—but inspires in them love for their creator and the creator of their world: Stalin. The withdrawal beyond the space of history that this entails allows history to be regarded as an allegory of the present that need not be negated so completely as the avant-garde had demanded. "Progressive" phenomena of the past and the accompanying artistic styles can then also be viewed as anticipating the creation of the new world and the figure of its creator, the "positive demiurge" Stalin, whereas "reactionary" social movements, figures, and styles anticipate the negative, demonic, destructive impulses of the avant-garde that were incarnated during the Stalin years in the figure of Trotskii and other "enemies of the people." Again, this reinterpretation of the past as a multitude of allegorical figures illustrating the present represents not a return to the past but the final overcoming of the "historical," real past which, for the avant-garde that strove to break free of it, constituted the horizon and background of contemporaneity.

Stalinist culture considered that it represented the only escape from history and that the rest of the world had not yet entered the realm of pure mythology but remained historical. And it was here that Stalinist culture encountered its limit—it was swept away by the forces of history, because unlike Christianity it had failed to establish itself in the superhistorical; and when the extrahistorical competes with the historical, it inevitably loses, because it is fighting on alien ground. Modern Russian postutopian art uses the lesson it has learned to make

this defeat obvious and final, overcoming the Stalin period by remythologizing and aestheticizing it. At the same time, the art that continues actively and virulently to polemize with and demythologize Stalinism fails, for it shares with Stalinism the inadequately articulated utopian impulse. Indeed, the meaning of postutopian art is to show that history is nothing other than the history of attempts to escape history, that utopia is inherent in history and cannot be overcome in it, that the postmodernist attempt to consummate history merely continues it, as does the opposite aspiration to prove that historical progress is infinite. Postutopian art incorporates the Stalin myth into world mythology and demonstrates its family likeness with supposedly opposite myths. Beyond the historical, this art discovers not a single myth but an entire mythology, a pagan polymorphy; that is, it reveals the nonhistoricity of history itself. If Stalinist artists and writers functioned as icon painters and hagiographers, the authors of the new Russian literature and art are frivolous mytho*graphs*, chroniclers of utopian myth, but not mytho*logists*, that is, not critical commentators attempting to "reveal the true content" of myth and "enlighten" the public as to its nature by scientifically demythologizing it. As was already stated above, such a project is itself utopian and mythological. Thus the postutopian consciousness overcomes the usual opposition between belief and unbelief, between identifying with and criticizing myth. Left to themselves today, artists and writers must simultaneously create text and context, myth and criticism of myth, utopia and the failure of utopia, history and the escape from history, the artistic object and commentaries upon it, and so on. Just as Keyserling predicted when he said that he was not worried about Stalin and Hitler, because eventually all Europeans would enjoy the rights reserved to these two men alone, the death of totalitarianism has made us all totalitarians in miniature. As these rights spread, of course, they also became obligations: only for a limited time can the loss of totality be referred to indirectly, through a "difference" or negative utopia. In the final analysis, it must be privately restored, as Kabakov

says in each successive reenactment of the sacred history of the avant-garde and its defeat.

Since the myth of Stalin as the demiurge of the new life is at the center of Stalinist culture, and since it has its source in the avant-gardist myth, it is appropriate by way of conclusion to say a few words about myth in general and define the notion of myth as such. It is commonly thought that myth and the avant-garde are opposites, or rather that the avant-garde struggles with myth and that because Stalinism generates myth it cannot be the heir of the avant-garde.

Especially useful in a discussion of the notion of myth is Roland Barthes's *Mythologies*, which both marks the beginning of the systematic study of modern myths and can itself be regarded as mythological. For Barthes, myth is "depoliticized speech," history made Nature, or the inversion of *anti-physis* into *pseudo-physis*.[1] In other words, myth describes that which exists as eternal and "natural"; it is directed toward the preservation of the statusquo and conceals the historical "madeness" of a world that can also be historically remade. Thus for Barthes myth is always rightist, always on the side of the bourgeoisie. Myth is "stolen speech"—stolen from the working class directly involved with the making of things, and appropriated by the bourgeoisie (Proudhon's "property is theft" comes to mind here).

Myth is the opposite of revolution, which returns language to its immediate function of "making" things and the new world as a whole. As Barthes notes: "There is . . . only one language which is not mythical, it is the language of man as a producer: wherever man speaks in order to transform reality and no longer to preserve it as an image . . . myth is impossible."[2] Revolution, therefore, which is a "making" of the world, is "antimythological": "Revolution announces itself openly as revolution and thereby abolishes myth."[3] The alternative to the language of myth is thus political language directed toward political action. Opposition to myth comes from the left. Although Barthes acknowledges the existence of myth "on the left" and takes the Stalin myth as an example, he

does not attach any particular importance to it. He maintains that left-wing myths are merely invented on the analogy of and in order to combat those on the right. There is nothing so terrible about this, for the artificiality and clumsiness of left-wing myths renders them relatively harmless.[4] Barthes also considers that avant-garde poetry is opposed to myth because it "works with language" and does not use it merely to convey a figurative content.

On the level of refined structural analysis, Barthes to some extent reproduces here the structure of Stalinist culture itself: myths are divided into right and left, "theirs" and "ours," and are judged accordingly. At the same time, however, he obviously sympathizes more with the aesthetic theory and practice of the avant-garde and its aspiration to remake the world, and he is reconciled to the myths on the left as merely an inescapable transitory evil. What is surprising about his contrasting of myth and the making or transforming of the world, however, is that it contradicts the obvious fact that what all significant known myths tell about is the creation and transformations of the world: a static, unchanging, unhistorical world cannot be narrated in myth. The reason for Barthes's strange reasoning becomes understandable if it is realized that he regards myth as the metalanguage that describes the "object-language." That is, for him myth is a theoretical entity. In actual fact, however, if myth does have any relevance to theory, it is only as a narrative about the creation of theory; it thus has a legitimizing function, especially in our age, when new descriptions of the world are in effect equated with its creation and are themselves incorporated into traditional mythology.

If, contrary to Barthes, myth has to do with the creation and transformations of the world, however, then it is precisely the avant-garde and leftist politics that are mythological, since by casting the artist, the proletariat, the party, the leader in the role of demiurge, they provide for their natural integration into world mythology. This is now acknowledged to some extent by Western Marxists, who are prepared to admit parallels between Marxist narrative, Christian historicism, and ancient magical practices.[5] Because people are incorporated by Marx-

ism in a unified mythological narrative about the creation of
the objective world through labor, they can transcend the
bounds of their earthly determinacy and, by altering the con-
ditions of their existence, change themselves, become the
"new humans." Marxism seems antimythological when it in-
sists that human existence must be understood in its social
relationships. However, revolutionary Marxism—and in an-
other respect, avant-garde art—are placed in a mythological
context by the very possibility of such a description (which
presuppose a view from "outside" the world) and the fact that
this description can be used to replace the context with an-
other through revolution. We would not escape myth even if
we were to follow the current fashion which rejects the princi-
ple of creation as bourgeois and mythological and declares the
social, lingistic, etc. context of human existence to be unlim-
ited and not subject to transformation. Reference to the world
as a whole is still preserved, as is the possibility of relating
one's practice to it, even if this practice is no longer "construc-
tive" like that of the avant-garde, but is "deconstructive" and
relativizes every creative effort. This, as has already been men-
tioned, is in turn a new postmodern utopia, a new attempt to
leave history and enter the eternal extrahistorical play of
codes.

The above, of course, should not be taken to mean that
myth is in actual fact entirely on the left rather than on the
right. Wittgenstein has shown that the essentially "rightist"
demand to abandon "metaphysical questions" results in a
kind of mythologization of the everyday as the sole area of
action (contrary to Barthes, who obviously has Wittgenstein
in mind, it is the object-language rather than the language of
description that Wittgenstein regards as mythological). Thus
there is no escaping myth, least of all in the avant-garde, revo-
lution, remaking the world, and so on. This circumstance does
not seem to be directly related to Stalinist culture. Yet in a
situation in which there has been an external break with the
mythological tradition, through its obvious objective of re-
vealing a new mythology, this culture enables at least those
who have experienced it to relate in a new way to myth as

such. In a situation where the context has changed even more decisively than the text, and where world history has been told anew, Soviet artists and writers can no longer naively believe that the history of their own liberation is reality rather than mythological ritual.

It proved impossible to break free of Stalin without reiterating him at least aesthetically. Consequently, modern Russian art has approached Stalin as an aesthetic phenomenon in order to repeat him and thus liberate itself from him. By constructing both text and context, practicing both construction and deconstruction, simultaneously projecting utopia and transforming it into antiutopia, it is attempting to enter the mythological family so that it may relate to Stalin not with *ressentiment* but with a feeling of superiority: every family has its black sheep.

Revealed in this frivolous, irreverent play is the colossal potential of desire and the unconscious that was inherent in the Russian avant-garde but was insufficiently recognized because it was encoded in a rationalistic, geometric, technical, constructive form. The machines of the avant-garde, however, were in reality machines of the unconscious, machines of magic, machines of desire—they were meant to process the artist's and viewer's unconscious in order to harmonize and save them through union with the cosmic unconscious. It was not until the Stalin years, however, that their true purpose began to become apparent, and then only partially. The term "machine of desire" suggested by Deleuze and Guattari is in fact defined by them very much in the spirit of Wittgenstein and Barthes: "The unconscious poses no problem of meaning, solely problems of use. The question posed by desire is not "What does it mean?" but rather *How does it work?*" . . . The greatest force of language was only discovered once a *work* was viewed as a machine, producing certain effects, amenable to a certain use."[6]

Deleuze and Guattari, of course, think that they are once and for all rid of the "subject" and of all "consciousness" and mythology. All they are doing in reality is repaving the way for the "engineers of human souls," the designers of the uncon-

scious, the technologists of desire, the social magi and alchemists that the Russian avant-gardists aspired to become and that Stalin actually was. The privilege of the context over the text, the unconscious over consciousness, the "other" over the subjective, or all that is known as the "unsaid" (*non-dit*) and "unthought" (*impensé*) over the individual human being merely means the dominance of the person who speaks about, or even more precisely, the person who actually works on, this context, this unconscious, this other, this unsaid. If such work succeeds in creating an artificial unconscious, an artificial context, and new and as yet unseen machines of desire called, say, "Soviet people," then these persons will suddenly be able to lead lives and generate texts that do not differ from natural ones, rendering irrelevant both the distinction between natural and artificial and all the effort expended on it. And these amazing beings with an artificial unconscious but a natural consciousness will also be capable of deriving aesthetic pleasure from contemplating this unconscious of theirs as a work of art created by someone else. In the most tasteless pettybourgeois tradition, they will thereby transform the avantgarde's unique and horrible feat—the creation of Stalinist art—into an object of frivolous amusement.

AFTERWORD

This book was written in 1987. By that time the decline of the Soviet Union had become obvious, and its looming collapse was easily predictable. Thus, that historical moment seemed to offer a good opportunity to write a book that would recapitulate the history of the Soviet Communist project. When I say "the history of the Soviet project," I do not mean the history of the Soviet Union, Soviet culture or, even, Soviet art—even if this book is mostly concerned with artistic matters. The book was not conceived as a historical narrative that should describe and interpret important facts of Soviet history. Rather, its goal was to ask the following question: what has happened to the project of building a completely new society, announced by the October Revolution and then implemented by Soviet power?

The first step was, of course, to define this project, because communism in general and Soviet Communism in particular could be and historically were defined in many different ways. During the process of writing I concentrated predominantly on what I thought—and still think—is the decisive and, at the same time, historically unique aspect of the Soviet experiment. Essentially, the Soviet project was a project to break with nature, including human nature, and to build the new society as a completely artificial construction. Herein lies the main difference between the Soviet project and many other revolutionary or counterrevolutionary projects that are known to us from history.

The bourgeois French Revolution appealed to nature as a source of inspiration and ideological legitimization. It had its intellectual roots in the ideas of "natural man" and "natural law" as opposed to divine law. The Nazi movement was ideologically based on race theory, which also perceived nature as the ultimate horizon of any possible

historical action. Soviet power, on the contrary, demonstrated permanently and on different levels of its political and economic practice, a deep, almost instinctive aversion toward everything natural. The campaigns against genetics and psychoanalysis are as characteristic in this respect as the collectivization of agriculture in the 1930s, aimed at uprooting the peasants and severing their traditional, intimate attachment to the earth. Some roots of this dislike for nature are to be found in the Russian Orthodox faith and in the Russian intellectual tradition of the nineteenth century. And, of course, some roots can be found in a Marxism that divided society not into races but into classes—so that the place in which a human being was situated in the framework of the technologically organized production process became more important than that human being's natural make-up. This Marxist analysis seemed to the Soviet theorists to promise a complete break with everything natural in mankind. It would render people completely malleable, totally flexible as they were assigned different positions in the system of socialist production. In the best Hegelian tradition, the human being as such was understood by Soviet ideology as a pure potentiality, a fluid nothing that becomes something only if it is given a certain function, a certain role in the process of socialist life-building.

Now, this will toward radical artificiality inscribed the Soviet Communist project in the context of art. The Soviet political project was at the same time an artistic project. The Russian proletariat was to be freed from the alienated work it had to carry out under the conditions of capitalist exploitation, with the goal of becoming a collective artist creating a new world—and at the same time (re)creating itself as its own artwork. Where nature was, art should be. The unity of the Soviet political and artistic project allows—indeed, necessitates—a discussion of this project in art-theoretical terms. And that is precisely what my book tries to achieve. It does not discuss Soviet art. It discusses the Soviet state itself as an artist and as an artwork. And, first of all, it discusses the basic artistic problems with which the Soviet state was

confronted—the same problems, in fact, that confronted every modern artist who undertook a similar artistic project. Ultimately, these problems can be reduced to a single one: how to define a relationship between one's own artistic practice and the artistic tradition? Modern art wanted to reject tradition, to break with it. But modern art had early on discovered its dependence on the past in at least two respects: firstly, it was dependent on the past because one is always dependent on that which one rejects, but, secondly and much more importantly, the past itself can be described as a history of rejections of the past and thus of new beginnings—so that modern art's new beginning began to look like a repetition of the previous new beginnings. We know all the difficulties and paradoxes that affected modern art due to these insights. The same can be said about the Soviet Communist project.

In the context of the Russian culture of the twentieth century and, in fact, also in the international cultural context, the Russian avant-garde took the most uncompromising and at the same time influential stand against nature and everything natural. Already before the Revolution, the artists of the Russian avant-garde proclaimed their definitive "victory over the sun"—that is, victory over a nature symbolized by the sunlight which was being replaced by the new, electric light. These artists understood themselves as "founding their art on nothingness," as having transcended the zero-point that divides the natural from the purely artificial. The artists of the Russian avant-garde called themselves futurists. But, unlike Italian futurism, the Russian avant-garde was not contaminated by any traditional concept of nation—nor by the fascination with modern technology and warfare. The ultimate goal of the Russian avant-garde was to create a New Man, a new society, and a new form of life. The whole issue of "elitist" vs. "popular" art, or of art for the few vs. art for the masses that was so relevant for Western art, was completely irrelevant for the artists of the Russian avant-garde, because they wanted to crush the elites and create new masses. Their problem was not how to create art that would be liked or disliked by elites or by the masses, but how to

create masses that would appreciate good—namely, avant-garde—art. The Russian avant-garde did not want to submit its artistic practice to the aesthetic judgment of the public, but rather to submit the public to its aesthetic judgment. And its problem was not how to criticize power, but how to take power and to execute this power in the most radical way. Russian avant-garde art understood itself not as critical art, but as powerful art, able to shape the fate of the Russian population and of the whole world. This attitude was also that of Stalinist Socialist Realism. Socialist Realism did not seek to be liked by the masses—it wanted to create masses that it could like. Generally, the public gets the art that it deserves. But Socialist Realism tried to produce the public that would deserve it.

When this book first appeared, I was often criticized for highlighting similarities between the Russian avant-garde and Stalinist Socialist Realism. Some readers understood this focus as an attack on the Russian avant-garde, an attempt to make it responsible for the terror of Stalin's epoch. At the same time, other readers interpreted my description of these similarities as an attempt to aestheticize the Stalinist regime, to suppress the memory of its crimes. And almost all of my critics found any comparison between the Russian avant-garde and Socialist Realism implausible, because of the visual differences between the two productions. Sure enough, a black square by Malevich and a Stalin portrait by, say, Alexander Gerassimov seem to have nothing in common. The fact that Malevich himself produced numerous figurative paintings during the 1920s and 1930s was mostly understood as his concession to "totalitarian aesthetics"—notwithstanding the fact that Malevich's late, "passéist" figurative canvases that mourned the fate of Russian peasants and celebrated the humanist ideals of the Renaissance, were, de facto, much more radically opposed to the artistic strategy of Socialist Realism than his earlier, futurist, optimistic Suprematism. Now, this fact alone illustrates the danger of a comparison between the avant-garde and Socialist Realism in purely formalistic terms—without

an adequate understanding of the concrete political projects in the context of which certain forms were embedded and used. It is not the artworks respectively produced by the Russian avant-garde and Socialist Realism that are compared in my book, but rather their respective political strategies. For these strategies are comparable, and, as I tried to show, they are in many ways similar. It is precisely this similarity that led to the suppression of the avant-garde by Stalinist culture. This kind of violent suppression can only be applied to a political rival in a struggle for power—a rival with the same goals as your own. So, this suppression alone is strong evidence of the affinities between the Russian avant-garde and Socialist Realism.

Some will say that it is precisely this use of suppression, political intimidation and terror that differentiates Stalinist culture from the period of the Russian avant-garde: after all, the latter artists did not kill anybody, although some of them were killed or at least placed under immense political, economic and social pressure by the Stalinist regime. However, it might be pointed out that the theoreticians, writers and artists of Socialist Realism did not kill anybody either. They simply accepted the physical destruction of their rivals and opponents by the regime; in fact, many of them would become the next victims of this regime. And, in this context, it should be said that the artists of the Russian avant-garde were also at least indifferent to the physical destruction of their rivals and opponents, during the period of the post-revolutionary Red terror that preceded the Stalinist terror. And it is reasonable to assume that these rivals and opponents would not themselves have complained very loudly had the White terror triumphed. These factual and counterfactual body counts can be prolonged indefinitely—accompanied by the usual mutual accusations and incriminations. Russian culture has produced a lot of such body-count literature, and continues to do so, at a high speed. Like every other Russian reader, I absorbed a great deal of this literature—and at least because of that I did not want to write another body-count book. Some may think that this decision demonstrates a certain moral insensitivity and cynicism on my

part. But if it is morally permissible to write about aspects of Christian theology without mentioning the number of victims of the Inquisition or the Crusades, or to write about democracy and human rights without quantifying the number of citizens who lost their heads to the guillotine in the name of those values, then it must also be possible to write about the Soviet Communist project while leaving readers who are interested in the Communist body count to satisfy their curiosity by turning to the numerous books devoted to precisely such grisly calculations.

This book is not, therefore, a history of the Soviet reality. It is, rather, a history of the Soviet imagination. The limitations of and difficulties with a certain project do not begin with its implementation, or with its realization. They emerge already at the stage of the project's formulation. The project to overcome nature, the status quo, or reality-as-it-is has to be formulated in certain media, linguistic and visual. Now, one can suppose that to design a new world one can and must transform the media in which such a design is formulated, and create a new language and art by the exclusion of everything that could be found in the past history of these media. Such was the project of the Russian avant-garde. It wanted to begin to build the new world by throwing away the accumulated ballast of the past—past words and past images. The avant-garde understood the Revolution as a radical break with the past, including the past of the media in which the vision of the future was to be formulated.

But the Communist Party saw its own revolution not as a break with the past but as an act of activation of revolutionary traditions and visions of the future that were stored in mankind's cultural memory—and had to be rendered actual and productive. That is why Socialist Realism found the approval of the Communist Party apparatus. For the theorists of Socialist Realism, the vision of the future completely purged of cultural traditions seemed simply impoverished, too one-dimensional, too restrictive, prohibitive and repressive. The transition from the Soviet 1920s to the period of Socialist Realism is often described as a move from creative

freedom and plurality of art movements toward an era of restrictive policies, censorship and officially imposed aesthetic homogeneity. But one should not forget that this variety of artistic movements, this panorama of different styles could be seen only from the perspective of the passive, disinterested spectator. It is precisely this detached, purely contemplative position that was fought against equally by different versions of the Russian avant-garde and by Socialist Realism. Every Soviet citizen was to be involved in the building of the Socialist future—and that meant for him or her to take sides, to opt for or against a certain artistic vision of this future. Now, looking not from the position of a disinterested spectator but from that of an engaged participant, it becomes apparent that the Socialist Realist paradigm was less restrictive and more inclusive than, say, the Suprematist one because it was allowed to operate with a much richer vocabulary of artistic forms, including forms appropriated from the traditions of the past. The conflict between the Russian avant-garde and Socialist Realism was actually centered on the legitimacy of artistic appropriation—and that conflict is characteristic of all art history of the twentieth century. For the avant-garde, of course, appropriation equaled plagiarism. To design the vision of the future using words and images taken from the past meant, for the artists of the avant-garde, to poison this vision with the gifts of the past. In the framework of Socialist Realism, appropriation was regarded as a legitimate artistic practice.

The way in which language and images are used defines the fate of any Utopian vision. These media allow the Utopian vision to emerge and at the same time impose constraints on this vision, long before any attempt at its realization can be undertaken. The subject of the Utopian and revolutionary imagination is necessarily confronted with difficult choices concerning the use of the media that allows this imagination to manifest itself. We know well enough to what extent the necessity of making these choices created a divide between leftist political revolutionary movements and leftist artistic movements, not only in the Soviet Union but also in the

West. This book tries to elucidate these choices and to describe the drama of the revolutionary imagination as it unfolded in twentieth-century Russia—a place where making a certain choice concerning one's imagination could be paid for by the real loss of one's life.

In the third part of the book, I analyze the contemporary Russian artistic practices in which the visual language of the Utopian imagination were thematized. At the time of its first publication, the names of Ilya Kabakov or Erik Bulatov did not mean much to Western readers—with the result that this section was almost completely overlooked by the critics, who concentrated their attention on the more familiar topics of the Russian avant-garde and Socialist Realism. But for me, personally, this third part was the most important, precisely because it undertook to introduce Western readers to a new Russian art that was not yet known abroad. I hope that now, as this art has become more familiar to Western audiences, the book will also be read in a somewhat different way: namely, as a historical genealogy of the problems with which Russian art had to deal during the late Soviet era.

But, of course, the question can be asked: is it desirable at all to attempt to build a new, artificial society in a revolutionary way, instead of letting the natural organic development of individual national states follow their own, historical, evolutionary paths? Indeed, the currently dominant mode of describing the period of Soviet Communism in the post-Socialist countries of Eastern Europe is to regard it as nothing more than an interruption, interval or delay in the continuous "normal" development of these countries—a hiatus which, once it was over, left no trace other than a certain appetite to "make up for lost time." Seen from this perspective, communism appears once again as the specter of itself, the haunting embodiment of a nothingness that, following its collapse, just evaporated into thin air. The artificial character of Soviet Communism makes it extremely difficult to inscribe into "natural" national histories. Every history has to have a subject to which this history is described. However, there is no longer a nation that can be described as a "Communist" or

"Sovjet" nation. They disappeared together with the communist project that constituted them, dissolving into particular, ethnically defined nations, the Russian, the Ukrainian, the Albanian and so on.

But if it is difficult to deal with artificial societies, it is at the same time impossible not to deal with them. Meanwhile, Western societies likewise understand themselves less and less as products of organic historical development, and more as "democratic" political models based on universal values. This redefinition of Western democracies as universal models reminds one of their own revolutionary, violent origins and renders them exportable—peacefully, as in the case of the post-Communist countries of Eastern Europe, or violently as in the case of Iraq or Afghanistan. It is easy to deplore this kind of exporting of political models as naïve. On the other hand, there are other artificial social models competing on the global political market: socialist, Islamic or fascist models, for example. And one can only escape the choice between them by inventing a new artificial social and political model. The Soviet experiment in building an artificial society inaugurated a new epoch of political imagination that is far from closed. Here, the art of politics transforms itself into the politics of art—political imagination being assimilated to artistic imagination.

August 2010

NOTES

INTRODUCTION
THE CULTURE OF THE STALIN ERA
IN HISTORICAL PERSPECTIVE

1. René Descartes, *Discours de la méthode* (Paris, 1966), pp. 43–46.

2. On the history of sots art, see *Sots-Art, Exhibiton Catalogue*, The New Museum of Contemporary Art (New York, 1986).

CHAPTER ONE
THE RUSSIAN AVANT-GARDE

1. Kazimir Malevich, "On the New Systems in Art," in his *Essays on Art*, ed. Troels Andersen, trans. Xenia Glowacki-Prus and Arnold McMillan (Copenhagen, 1968), vol. 1, p. 85.

2. Kazimir Malevich, "Introduction to the Theory of the Additional Element in Painting," in his *The Non-Objective World*, trans. from German by Howard Dearstyne (Chicago, 1959), pp. 18–20.

3. Quoted in Karsten Harries, "Das befreite Nichts," in *Durchblicke. Martin Heidegger zum 80. Geburtstag* (Frankfurt am Main, 1970), p. 46. On the significance of white in Malevich, see p. 44.

4. Kazimir Malevich, "The Question of Imitative Art," in *Essays on Art*, vol. 1, p. 174.

5. Malevich, "God Is Not Cast Down," in *Essays on Art*, vol. 1, p. 188.

6. Ibid., p. 194.

7. Kazimir Malevich, *Bespredmetnyi mir* (original text), p. 7.

8. Ibid., p. 12.

9. Velimir Khlebnikov, "Zakon pokolenii," in his *Tvoreniia* (Moscow, 1986), pp. 642–52.

10. Velemir Khlebnikov, "Nasha osnova," in *Tvoreniia*, pp. 627–28.

11. See "Detstvo i iunost' Kazimira Malevicha. Glavy iz avtobiografii khudozhnika," in Jan Benedikt, ed., *K istorii russkogo avangarda* (Stockholm, 1976), pp. 85–129.

12. Vladimir Solov'ev, "Obshchii smysl iskusstva," in his *Sobranie sochinenii* (reprint, Brussels, 1966), vol. 6, p. 85.

13. B. Arvatov, "Language Creation (On 'Transrational' Poetry," in Anna Lawton and Herbert Eagle, eds. and trans., *Russian Futurism through Its Manifestoes, 1912–1928* (Ithaca, N.Y., 1988), pp. 217–32.

14. On the history of Russian constructivism, see Christina Lodder, *Russian Constructivism* (New Haven and London, 1983).

15. For the texts of these polemics, see Hubertus Gassner and Eckhart Gillen, *Zwischen Revolutionskunst und sozialistischem Realismus* (Cologne, 1979), pp. 52–56.

16. Quoted in Lodder, *Russian Constructivism*, pp. 98–99.

17. B. Arvatov, *Iskusstvo i proizvodstvo* (Moscow, 1926).

18. Ibid., p. 42.

19. Ibid., p. 9.

20. N. F. Chuzhak, "Pod znakom zhiznestroeniia," *LEF*, no. 1 (1923): 12–39. On the history of the notion of "life-building," see Hans Gunther, "Zhiznestroenie," *Russian Literature* 20 (1986): 41–48.

21. Chuzhak, "Pod znakom zhiznestroeniia," p. 36.

22. Solov'ev, "Obshchii smysl iskusstva," p. 84. See also Viacheslav Ivanov, "Dve stikhii v sovremennom simvolizme," in his *Sobranie sochinenii* (Brussels, 1979), Vol. 2, pp. 536–61.

23. Gassner and Gillen, *Zwischen Revolutionskunst und sozialistischem Realismus*, p. 286.

24. Chuzhak, "Pod znakom zhiznestroeniia," p. 39.

25. Malevich, "God Is Not Cast Down," p. 205.

Chapter Two
The Stalinist Art of Living

1. V. I. Lenin, "Party Organization and Party Literature," in his *V.I. Lenin on Literature and Art* (Moscow, 1978), p. 25.

2. On the history of the notion of "socialist realism," see Hans Gunther, *Die Verstaatlichung der Literatur* (Stuttgart, 1984), pp. 1–10, and H. J. Schmitt and G. Schramm, eds., *Sozialistische Realismuskonzeptionen. Dokument zum I. Allunionskongress der Sowjetschriftsteller* (Frankfurt am Main, 1974).

3. S. Tretyakov, "From Where to Where," in Lawton and Eagle, eds., *Russian Futurism through Its Manifestoes, 1912–1928*, pp. 206–207.

4. V. I. Lenin, "On 'Proletkult' and Proletarian Literature," in *V. I. Lenin on Literature and Art*, pp. 167–69.

5. Aleksandr Bogdanov, "The Proletarian and Art," in John E. Bowlt, ed. and trans., *Russian Art of the Avant-Garde. Theory and Criticism, 1902–1934* (New York, 1976), pp. 176–77.

6. See Gunther, *Die Verstaatlichung der Literatur*, pp. 144–69.

7. Members of the group included M. Larionov, N. Goncharova, and I. Zdanevich. See B. Livshits, *The One-and-a-Half-Eyed Archer* (Newtonville, Mass., 1977).

8. Andrei A. Zhdanov, *Essays on Literature, Philosophy, and Music* (New York, 1950), pp. 88–89, 96.

9. G. Vinokur, "Revolutsionnaia frazeologiia," *LEF*, no. 2 (1923): 109.

10. Ibid., p. 110.

11. G. Vinokur, "Futuristy—stroiteli iazyka," *LEF*, no. 1 (1923): 204–13.

12. V. I. Lenin, "Critical Remarks on the National Question," in *V. I. Lenin on Literature and Art*, pp. 88–102.

13. W. Kemenow, "Stellung und Bedeutung der Kunst und Literatur im gesellschaftlichen Leben," *Kunst und Literatur*, no. 1 (1953): 28.

14. Ibid., p. 28.

15. W. Ketlinskaja, "Beim Studium des Materials des XIX. Parteitages," *Kunst und Literatur*, no. 1 (1953): 39.

16. Kemenow, "Stellung und Bedeutung der Kunst und Literatur," p. 31.

17. Ibid., p. 29

18. N. Dmitrieva, "Das Problem des Typischen in der bildenden Kunst," *Kunst und Literatur*, no. 1 (1953): 100.

19. B. Ioganson, "O merakh uluchsheniia uchebno-metodicheskoi raboty v uchebnykh zavedeniiakh Akademii khudozhestv SSSR," *Sessii Akademii khudozhestv SSSR. Pervaia i vtoraia sessiia* (Moscow, 1949), pp. 101–103.

20. Ibid.

21. Ibid.

22. Dimitrieva, "Das Problem des Typischen."

23. A. M. Gerasimov, "Zakliuchitel'noe slovo [?]" *Sessii Akademii khudozhestv SSSR*, p. 270.

24. Ia. Tugendkhol'd, *Iskusstvo oktiabor'skoi epokhi* (Leningrad, 1930), p. 24.

25. Ibid., p. 24.

26. On will and passion in Stalinist aesthetics, see Igor Smirnov, "Scriptum sub specie sovietica," *Russian Language Journal* 41, nos.

138, 139 (Winter–Spring 1987): 115–38, and V. Papernyi, *Kultura 2* (Ann Arbor, 1985), pp. 119–70.

27. The heroes of Nikolai Ostrovskii's *How the Steel Was Tempered* and Boris Polevoi's *A Story about a Real Man*, respectively.

28. Tretyakov, "From Where to Where?" p. 206.

29. Quoted in Livshits, *The One-and-a-Half-Eyed Archer*.

30. Katerina Clark, *The Soviet Novel: History as Ritual* (Chicago, 1981).

31. On the sacred dimension of Khlebnikov's poetry, see Aage Hansen-Löve, "Velimir Chlebnikovs Onomapoetik. Name und Anagramm" (manuscript).

32. Tugendkhol'd, *Iskusstvo oktiabr'skoi epokhi*, p. 31.

33. The texts on Lenin's style are in *LEF*, no. 1 (5)(1924): 53–104.

34. See Clark, *The Soviet Novel*, pp. 141–45, and A. Siniavskii, "Stalin—geroi i khudozhnik stalinskoi epokhi," *Sintaksis*, no. 19 (1987): 106–25.

35. L. Reingardt, "Po tu storonu zdravogo smysla. Formalizm na sluzhbe reaktsii," *Iskusstvo*, no. 5 (1949): 77–78.

36. Cf. Martha Rosler, "Lookers, Buyers, Dealers, and Makers: Thoughts on Audience," in Brian Wallis, ed., *Art after Modernism: Rethinking Representation* (New York: The New Museum of Contemporary Art, 1984), pp. 311–40.

37. N. Dmitrieva, "Esteticheskaia kategoriia prekrasnogo," *Iskusstvo*, no. 1 (1952): 78.

Chapter Three
Postutopian Art

1. Cf. B. Groys, "Der Paradigmawechsel in der Sowjetischen inoffiziellen Kultur," in D. Beyrau and W. Eichwede, eds., *Auf der Suche nach Autonomie* (Bremen, 1987), pp. 53–64.

2. Livshits, *The One-and-a-Half-Eyed Archer*. See also Rodchenko's vehemently "anti-Western" letters from Paris in "Rodchenko v Parizhe," *Novyi LEF*, no. 2 (1927): 9–21.

3. For reproductions of Bulatov's works, see *Katalog Erik Bulatow* (Kunsthalle Zurich, 1988). See Boris Groys's interview with Bulatov in *A-Ia*, no. 1 (1979): 26–33.

4. Friedrich Nietzsche, *The Gay Science* (Aphorism 125), in *The Portable Nietzsche*, trans. Walter Kaufmann (New York, 1980), p. 95.

5. Kazimir Malevich, "From Cubism and Futurism to Suprematism: The New Painterly Realism," in John E. Bowlt, ed., *Russian Art of the Avant-Garde: Theory and Criticism, 1902–1934* (London, 1988), p. 118.

6. Erik Bulatov, "Ob otnoshenii Malevicha k prostranstvu," *A-Ia*, no. 5 (1983): 26–31.

7. B. Grois, "Kartina kak tekst: 'Ideologicheskoe iskusstvo' Bulatova i Kabakova," *Wiener Slawistischer Almanakh* 17: 329–36.

8. B. Grois, "Albomy Il'i Kabakova," *A-Ia*, no. 2 (1980): 17–22. For reproductions and a general description, see *Katalog Ilya Kabakov "Am Rande"* (Kunsthalle Bern, 1985).

9. Il'ia Kabakov, "Semidesiatie gody" (manuscript).

10. Jacques Derrida, *Margins of Philosophy*, trans. Alan Bass (Chicago, 1982), p. 18.

11. Cf. the title of Kabakov's Bern exhibition, "Am Rande."

12. Jacques Derrida, *The Truth in Painting*, trans. Geoff Bennington and Ian McLeod (Chicago and London, 1987), pp. 60–61.

13. On the function of white in Kabakov, see *A-Ia*, no. 6 (1984).

14. For reproductions and a general introduction, see Melvyn B. Nathanson, ed., *Komar & Melamid: Two Soviet Dissident Artists* (Carbondale, Ill., 1979), and *Komar and Melamid*, Museum of Modern Art Catalogue (Oxford, 1985).

15. V. Komar and A. Melamid, "A. Ziablov (Etiud dlia monografii," in *Russica-81. Literaturnyi sbornik* (New York, 1982), p. 408.

16. Ibid., p. 404.

17. Ibid., p. 407.

18. Cf. Komar and Melamid's *Yalta 1945—Winter in Moscow 1977*, in *Documenta 8* (Kassel, 1987), vol. 2, pp. 132–33.

19. Interview with Noemi Smolik, *Wolkenkratzer*, no. 6 (1987): 48–53.

20. D. Prigov, *Literaturnoe A-Ya* (Paris, 1985), pp. 84–94.

21. Ibid.

22. Ibid.

23. Ibid.

24. See, for example, Jouri Mamleiev, *Chatouny* (Paris, 1986), and two of his stories in *Akzente*, no. 3 (1988): 244–59.

25. V. Sorokin, "Otkrytie sezona," in *Literaturnoe A-Ya* (Paris, 1985), pp. 60–62.

26. V. Sorokin, "Proezdom," in *Literaturnoe A-Ya* (Paris), pp. 65–67.

27. Mikhail Bakhtin, *Rabelais and His World*, trans. Helene Iswolsky (Bloomington, Ind., 1984), pp. 162–64.

28. V. Sorokin, "Norma" (manuscript).

29. Mikhail Bakhtin, *Problems of Dostoevskii's Poetics*, ed. and trans. Caryl Emerson (Minneapolis, 1984), pp. 140–42.

30. Sasha Sokolov, *Palisandriia* (Ann Arbor, Mich., 1985). For discussions of the novel, see Olga Matich, "Palisandriia: Dissidentskii mif i ego razvenchanie," *Sintaksis*, no. 15 (1986): 86–102; I. S. "Nepoznavaemyi sub"ekt," *Beseda*, no. 6 (1987): 127–43; A. Zholkovskii, "Vliublennye nartsissy o vremeni i o sebe," *Beseda*, no. 6 (1987): 144–77.

31. The hero's name evokes a wide range of associations: the author's name Aleksandr; Alexandria and its eclecticism (an allusion that is further reinforced through the form *Poly*sandria); and the Russian word for rosewood (*palisandr*), a symbol of the aristocratic tradition.

32. Cf. B. Groys, "Im Banne der Supermachte: Die Künstler in Moskau und New York," *Durch*, no. 2 (Graz, 1987), pp. 55–63.

33. Jacques Derrida, *D'un ton apocalyptique adoptie naguere en philosophie* (Paris, 1983), pp. 84–85.

34. "Eric Bulatov and Ilya Kabakov in Conversation with Claudia Jolles and Victor Misiano," *Flash Art*, no. 137 (November-December 1987): 82–83.

CHAPTER FOUR
DESIGNERS OF THE UNCONSCIOUS
AND THEIR AUDIENCE

1. Roland Barthes, *Mythologies*, trans. Annette Lavers (New York, 1987), p. 142.

2. Ibid., p. 146.

3. Ibid., p. 147.

4. Ibid., pp. 147–48.

5. Frederic Jameson, *The Political Unconscious* (Ithaca, N.Y., 1981), p. 285.

6. Gilles Deleuze and Felix Guattari, *The "Anti-Oedipus"* (New York, 1977), p. 109.

Printed in the United States
by Baker & Taylor Publisher Services